IMAGES OF
England

ELY

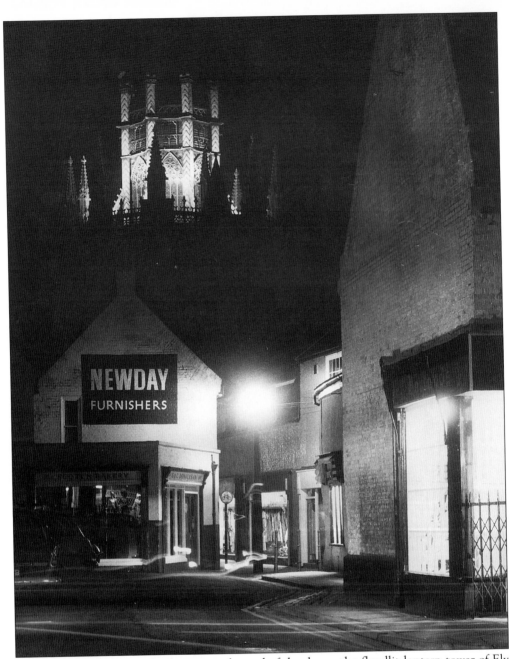

Newday's advertisement clearly seen at the end of the day as the floodlit lantern tower of Ely Cathedral floats above a corner, now sympathetically rebuilt and occupied by Thornhill's, the baker. On the other side of High Street Passage is Borland's shoe shop, Gidden's and The Passage Shop, both selling ladies' fashions. Newday, furnishers, occupied part of the building that went right along the east side of High Street Passage and had its main entrance in High Street. Williamson & Co., later Williamson & Dingle, grocers, A. Davison, clothier (from about 1905-1912), Hayward & Son, furnishers, (from about 1913 to 1961) occupied these premises until Newday moved there in 1982. Now after several changes, New Look ladies fashions occupies most of the retail area.

IMAGES OF
England

ELY

Compiled by
Pamela Blakeman and Mike Petty

TEMPUS

First published 1997, reprinted 2001
Copyright © Pamela Blakeman and Michael J. Petty, 1997

Tempus Publishing Limited
The Mill, Brimscombe Port,
Stroud, Gloucestershire, GL5 2QG

ISBN 0 7524 1007 5

Typesetting and origination by
Tempus Publishing Limited
Printed in Great Britain by
Midway Colour Print, Wiltshire

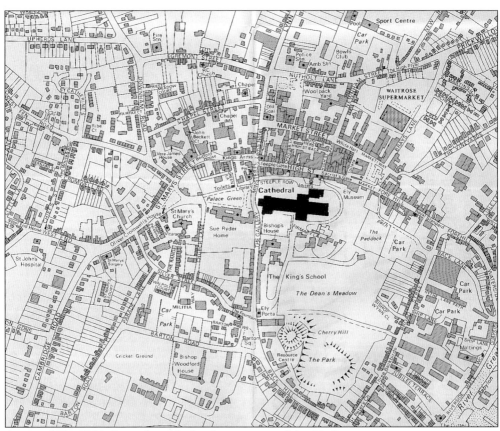

A map of Ely, 1994. Reproduced by kind permission of the Ely Society.

Contents

Foreword

I feel sure that this collection of photographs will appeal to Eliens of all ages but will be of special appeal to three groups. Firstly, to the more senior in age who so often bemoan the many changes which have taken place in and around Ely within the last fifty years. To them these photographs will bring back memories of the Ely they knew as children.

Secondly, to younger people who may know little of the community and traditions of their city in earlier days and, thirdly, to the many people who have made Ely their home in the last twenty or thirty years and are eager to know more about the city and its surroundings.

Pamela Blakeman and Mike Petty bring both knowledge and enthusiasm to this book which shows a city building on the heritage of its past as it moves into the twenty-first century.

The Reverend Canon Dennis Green,
Vice-Dean Ely Cathedral

Introduction

Ely, set on an island high above the low lying fen countryside, is both cathedral city and market town. Although there is some evidence to suggest an earlier settlement the present city has grown up around, and with, the monastery founded by St Etheldreda in 673. Etheldreda, daughter of King Anna, always wanted to become a nun but circumstances dictated that she should marry not once but twice. Her first husband, Tonbert, who had given her the Isle of Ely, died after a few years and so when she fled from her second husband, King of Northumbria, it was to Ely that she returned.

Nothing visible now remains of the abbey she founded for the relatively isolated community was sacked by the Danes about 870. After his victories in 1066 William the Conqueror found the conquest of the island a harder enterprise, defended as it was both by Hereward with his band of resistance fighters and by marsh and swamp. Both were eventually beaten.

Simeon, appointed by William I, came to Ely as its Abbot in 1081 and soon after began to build the present church. The Norman, or Romanesque, building was completed by the end of the twelfth century but before this, although it had remained a monastic church until the dissolution of the monastery at Ely in 1539, it had also became the church of the newly created Diocese of Ely in 1109. Many former monastic buildings are still in use today. After over nine hundred years the cathedral has been extended, the central tower fallen and replaced by Ely's unique octagon and lantern tower and many restorations have taken place. This great cathedral encircled by monastic buildings is proof of the success of William the Conqueror, the rich fertile land around the city testimony to the work of generations of drainers and farmers.

This book reflects on both village and town. Through the eyes and lenses of photographers we glimpse life in the high streets and back streets, in cathedral and chapel, in workhouse and palace. We see it from the river, long a route of great importance into the city, and from the settlements which cluster on the island of Ely.

The selection has been compiled by Ely historian Pam Blakeman and local historian Mike Petty. Both owe much to the enthusiasm of the late Reg Holmes whose collection of Ely memorabilia, with those of the authors, forms the basis for the core of the book, though supplemented with images from other collectors both amateur and professional.

Everywhere, be it in foreground or background, visible or unseen, is the presence of the cathedral, dominating the landscape and the city as it has done for nearly a thousand years.

Pamela Blakeman and Michael Petty
September 1997

Acknowledgements

We are grateful to all those local people who offered us photographs of Ely and surrounding villages and of course those who, though largely unknown, took the photographs including; Tom Bolton, J.F. Burrows, A.R. Denston, Len Edwards, Starr & Rignall, John Titterton and more recently Brian Lane and Donald Monk. Pictures have been supplied by Stanley Bye, Cambridgeshire Libraries and Heritage, Cambridge Antiquarian Society, the *Cambridge Evening News*, Ely Museum, Brian Lane, Donald Monk, Leslie Oakey, Ann Smith, Michael Rouse. Many pictures have also come from the authors' collections. As with all research on Ely we are particularly indebted to the late Reg Holmes.

A short list of books consulted

Ely Cathedral City and Market Town a pictorial record 1817-1934 by Mike Rouse and Reg Holmes (1972)

Ely Cathedral City and Market Town. The second in a series of pictorial records 1900-1953 by Mike Rouse and Reg Holmes (1975)

Ely in old picture postcards by Michael Rouse (1983)

The Book of Ely by Pamela Blakeman (1990, reprinted 1994)

Ely Inns by Reg Holmes (1984)

Ely & District by Chris Jakes (1995)

Ely Billheads by Pamela Blakeman (1984)

Ely Red Books (1983-1971)

Talking Pictures by Michael Rouse (1992)

Files from the *Ely Standard* and *Cambridge Evening News*

English Cathedrals The Forgotten Centuries by Gerald Cobb (1980)

The Victoria History of the Counties of England: Cambridge and Ely Volume Four (1967) R.B. Pugh (Editor)

One

Around
the Market Place

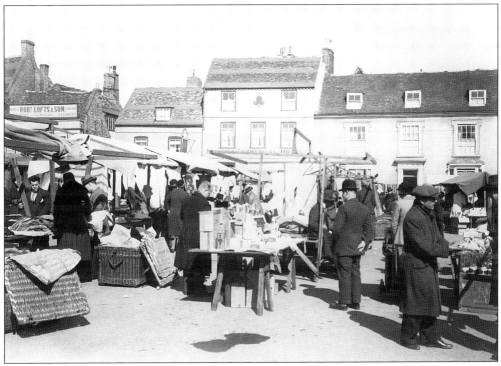

Market Day in 1933. In the background is part of the top of Robert Lofts & Son, decorators and plumbers, the Club Hotel (which closed in 1976), with its distinctive striped roof, and on the right an eighteenth century house seen again in the next picture. This was once the home of solicitor George Martin Hall, coroner, and was demolished in the 1930s to make way for a new cinema which was never built. A weekly market has been held on the present site, which once extended further west, since medieval times, though in 1801 the day was changed from Saturday to Thursday. Since 1993 when the square was resurfaced with brick, parking has not been allowed, and now a flourishing craft and antiques market is held on Saturdays.

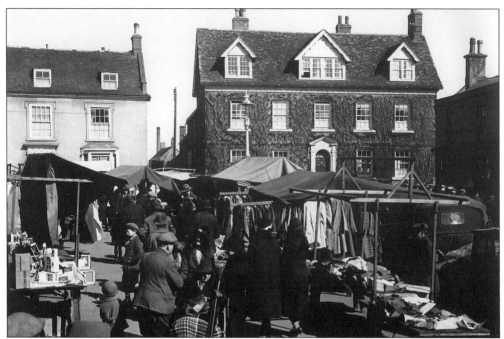

Archer House to the right has been occupied by Archer & Archer, solicitors in Ely since 1832; the building at that time known as the Mansion House. In 1785 Thomas Pennystone Archer was the first of the family to practice in Ely. Brays Lane, between this and Mr Hall's house, takes its name from the de Bray family who, in the thirteenth century owned an estate nearby which had an entrance from the Market Place.

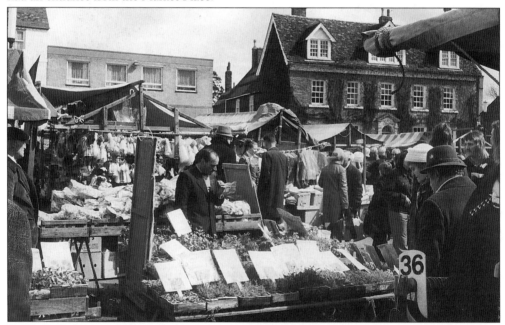

Since 1965 the site of Mr Hall's house has been occupied by the city's first supermarket, Tesco, seen here before 1996, when it was given a pitched roof and a new front to harmonise with surrounding buildings.

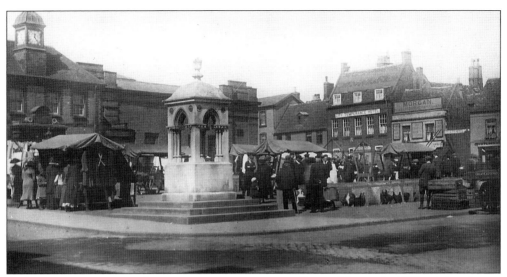

A fountain, in its original position, to commemorate Queen Victoria's 1897 jubilee. It was moved, in 1939, to Archery Crescent, Bray's Lane. It is seen here on a busy market day sometime around 1910.

Fisher's, jewellers, on the left of the Buttermarket, and D. and F. Supplies on the other side soften the impact of the new shopping development seen on the right. This is said to 'have shattered' the Market Place when it replaced buildings said by Pevsner to 'not spoil the character of a modest country town'. The square was divided with kerbed pavements supposedly to control car parking but which proved a stumbling block for the unwary on crowded Thursdays.

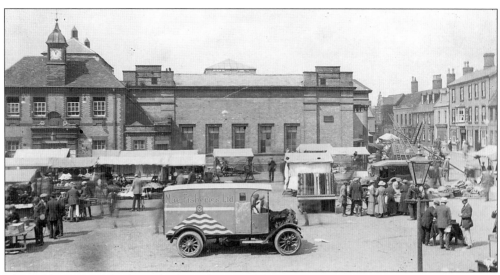

The Public Room, which was built on the site of the Sessions House from which five Littleport and Ely rioters were condemned to death, and the side of the Corn Exchange in 1920. Part of the Public Room building was first used for a poultry market, then in 1855 was converted into the Public Reading Room. Later in the century it was considerably enlarged, in 1910 a maple floor was laid for roller skating and in July 1919 the City Picture Hall opened. The Corn Exchange was built in 1847 and demolished 1964/5 to make way for the new development. It was only after the cattle market opened in 1846 (last sale of animals 1981) that the market stalls moved into the main part of the square from the front of the Corn Exchange.

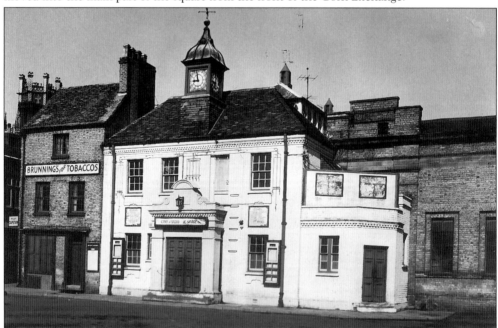

The Public Room, more correctly called the Exchange Cinema, at this time, when *The Thief of Baghdad* and *The Savage* were advertised; they were probably among the last films to be shown. The cinema closed on 13 May 1963 and was demolished about a year later. Note the railway timetable on the wall of Brunnings, tobacconist (formerly Dove's).

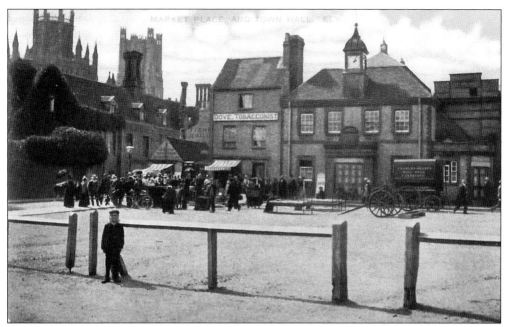

In about 1900, railings still defined the Market Place, Fisher's had yet to expand, Dove's, tobacconist, still occupied the three-storey building and the Public Room staged operatic and theatrical entertainments. Charles Sharpe, Mill Road, Cambridge had brought his horse-drawn van to Ely to sell furniture.

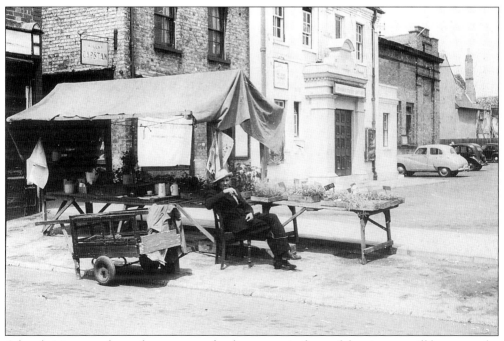

A lonely itinerant plant salesman poses for the camera in front of the cinema, still known as the Public Room in the 1950s.

Part of the Market Place, 1938. Archer House is in the distance but there is no longer a corresponding house (see pages 9 and 10) on the opposite corner of Bray's Lane.

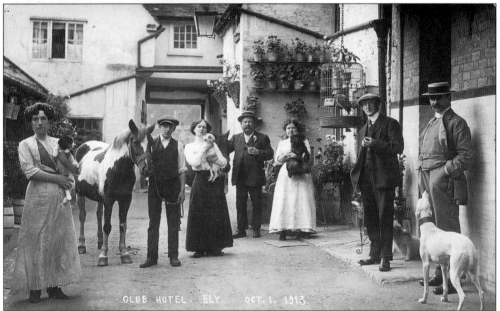

The group of people are standing inside The Club yard on 1 October 1913. The Club was converted to the Club Mews, a shopping precinct which opened in October 1981, but in 1997 the shops stand empty awaiting a proposed new development. The figure second from the left is Albert Tebbit, a champion fenland skater, who when the Amateur Championship took place in 1902 won the King Edward VII Cup outright and also held the Duddlestone Cup in 1895 and 1903.

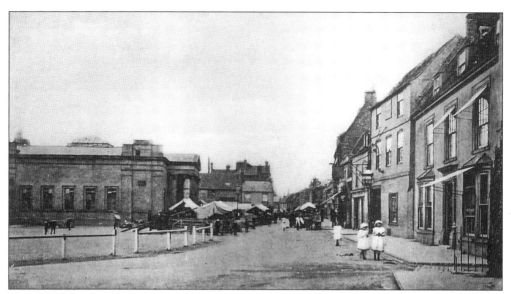

A similar view to the previous photograph but from a different angle looking down Market Street. The columns and pediment of the Corn Exchange are glimpsed above the stalls. On the corner of Market Street is Kempton's greengrocer's shop; Robert Kempton is said to have opened a general store on this site in 1592.

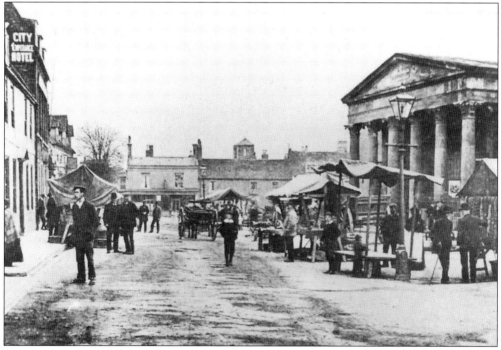

On the right the imposing facade of the Corn Exchange, built in 1849, is seen behind the market stalls. This view looks in the opposite direction with Nash's, grocers, general provisions and hardware in the distance where Cheffins, Grain and Comins estate agents is now. Above the roof of the present *Cambridge Evening News* office one of two 'look out' towers at the rear of Fore Hill that existed, certainly into the late 1930s, can be seen.

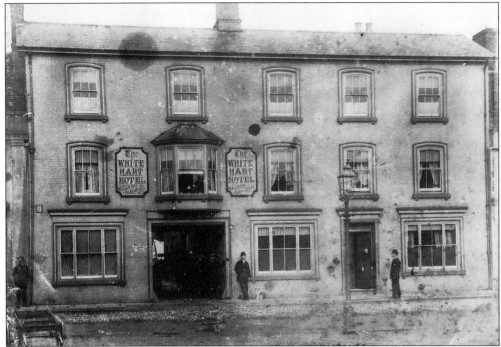

The White Hart Hotel, almost opposite the Corn Exchange, *c.* 1870 The ground floor to the left of the arch later became a butcher's shop and then a hairdresser's which closed in 1963. The facade of the building has been kept and the ground floor has been converted into shops but the archway, with its fifteenth-century timbers, is hidden until that unit is let.

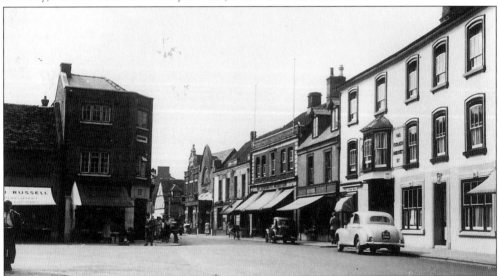

A photograph taken at the time when Joan Russell had a shop which sold 'perfumes and medicines', *c.* 1950. Next door is Kempton's, the three-storey building which replaced the earlier one (see page 15) in 1936, and on the right the White Hart, Mavis Rose hairdresser, Sykes' toy shop, Ely Co-operative Society premises, a building which had various uses from hairdressers to cafe, the Rex Cinema (closed January 1981), F. Bennet, a high class grocer's shop and the Woolpack Inn.

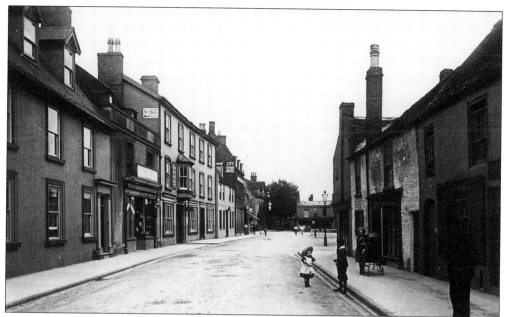

By now a familiar view which again shows the White Hart with, between it and the City Temperance Hotel, the home of Elizabeth and Mary Muriel. The two sisters were born at The Chantry, in Palace Green, daughters of John Muriel who had been a surgeon at the time of the 1832 cholera outbreak in the city. On the right next to Kempton's is a small cottage, Allpress's Tea Shop, and part of Peck's, ironmongers. The firm celebrated 150 years in 1996.

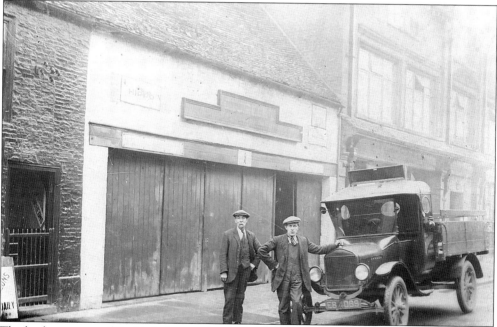

The back entrance of Peck's before modernisation in 1947/8; the old lorry was replaced at the same time. Beyond is the general post office, rebuilt in 1891, from which it relocated to a modern office facing the Market Place in 1966. This was abandoned in 1991 when the post office moved into Lloyd's, a chemist's shop in the High Street.

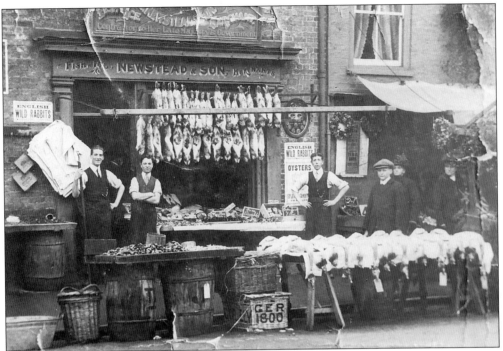

Just around the corner on the west side of the Market Place was Newstead and Son, shown here as purveyors of fish, game and poultry at a time when produce was conveyed by the Great Eastern Railway in baskets and hampers. The business closed in 1970 after eighty-three years in the city.

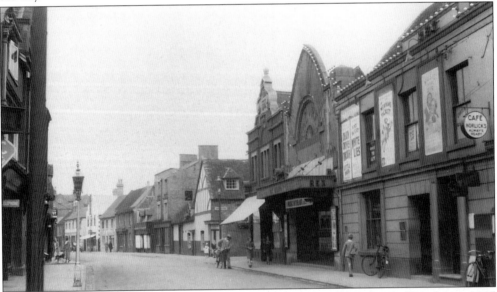

A closer look at the Rex cinema, now part of Boots the chemists, Bennet's (Dingle's in 1905 when it was built) now Brands and the Woolpack, c. 1935. Beyond, Matthews the jewellers with well restored early nineteenth-century detail, and Thurmotts, harness makers and other buildings, can be seen. The Rex facade was remodelled in the late 1930s some fifty years or so before it closed.

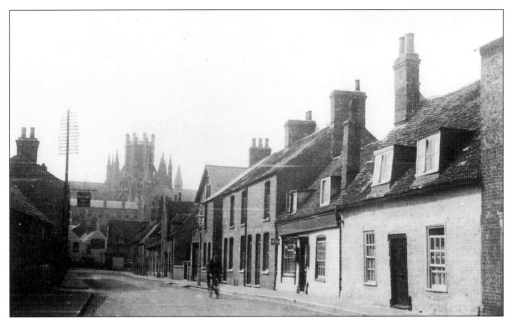

Looking along Newnham Street, towards Market Street, at a group of old cottages, now rebuilt, Stubbings' bakery and a private house, 1935. At this time between the Woolpack, on the corner, and the bakery there were twelve cottages.

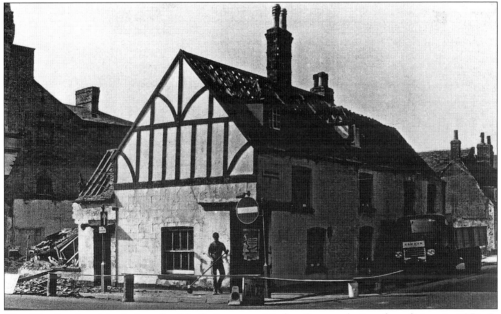

The Woolpack, with timbered gable facing onto Market Street, during demolition in 1971. It has been replaced by the National Westminster bank. Near the back of the lorry the single-storey building was the smokehouse of F. Tow, fish merchant. At the beginning of the twentieth century Tow's shop was at the western end of the Buttermarket.

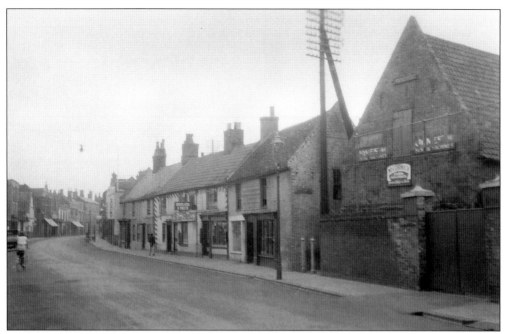

Looking along the south side of Market Street toward The Rex in 1935. On the right is the rear of Cutlack's premises, which stretched through to High Street, adjacent to a row of shops; Greenhill's, cycle agents, Steven's barber's and three premises occupied by E. Dean, plumber.

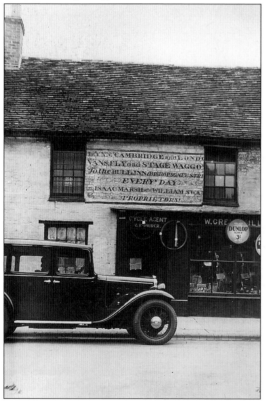

A view of the present Stage Coach restaurant seen in 1934. During refurbishment in April 1922, this old sign, advertising the Stage Waggon which carried goods to and from Cambridge daily, was revealed.

Two

Roads to Lynn and Cambridge

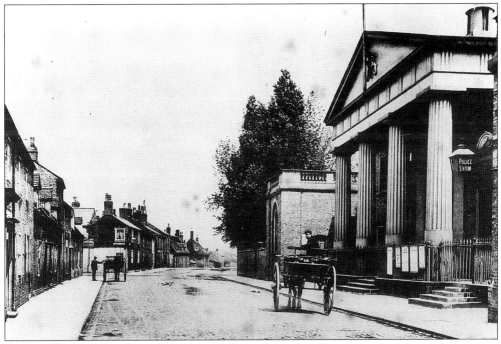

Shire Hall, when it was built in 1820. It is now the Sessions House. On the left, the west side of Lynn Road stretches into the distance. Thatched cottages have been replaced by a large warehouse type building used until the 1970s by F.A. Standen & Sons Engineering Ltd and then as furniture showrooms. It now stands empty and almost derelict.

Lynn Road in 1902. Lynfield Terrace built sometime around 1887 is on the right, beyond which there appears to be a gap before the Tinker of Ely. This is the area known as Little London where the cottages were set back from the road; the same building line is followed here today.

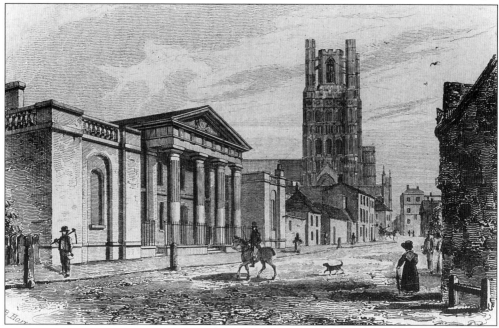

An earlier view of Shire Hall looking to the south with the west tower, the former Bishop's Palace and the Lamb Hotel. Just beyond Shire Hall, on the corner of Market Street, is the Old Gaol which was the Bishop's prison from sometime around 1679 to 1836 when the jurisdiction of the Bishops of Ely was abolished.

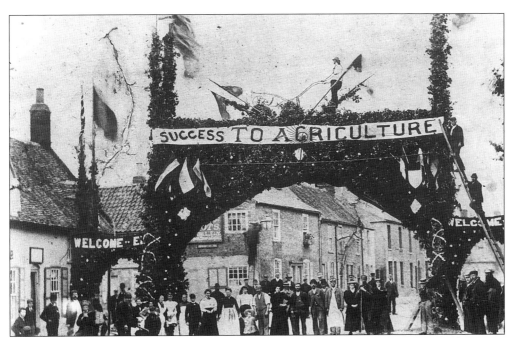

One of two archways placed across the road to mark the Agricultural Show in 1887. This one is over the Lynn Road near the former King William IV (closed 1962), on the corner of Egremont Street.

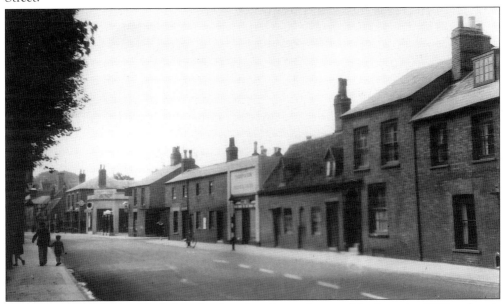

The houses have changed little but the shop has changed ownership since the 1930s, when it was occupied by Tharby & Son, tailors, who remained there for over twenty years. The premises, after various changes, are now divided between Mr Escobar-Franco's chiropody practise and a dental care studio. The George and Dragon which was on the far corner of Chapel Street has been demolished. The garage, Ely Service Motor Company, after sixty-four years moved its businness to Lancaster Way in 1994. The premises are now used by the Ely Christian Fellowship.

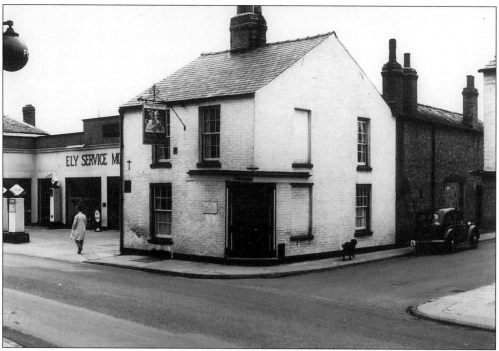

The George and Dragon had been on this site for at least 150 years when it closed in June 1978. On the left is the blue lamp of the police station.

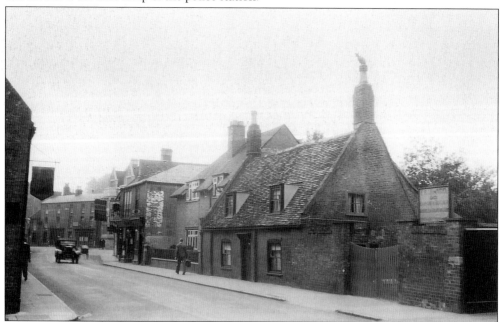

Looking towards the Lamb Corner. The corner shops are hidden by the Walbro, cycle and radio works, which was run by Horace Wallis and remembered by many, as a place where wireless accumulators could be recharged in the 1930s and 40s. Ken Wallis, son of the owner, invented and flew the auto-gyro used in the James Bond films. The dormer-windowed cottage has been demolished and the stonemason's yard, nearest to the camera, is now a private car park.

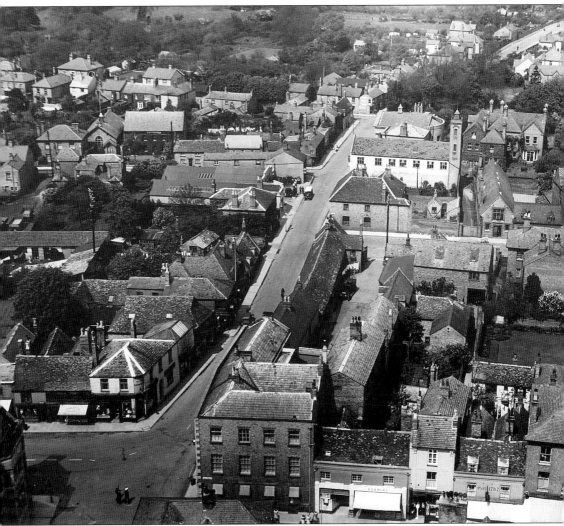

High Street to Lynn Road in the 1920s. The long white building beyond the Old Gaol, almost opposite Ely Service Motor Co. garage, was the office of the Urban District Council, built in 1931, with the fire station below. The tower at the back of the building dates from 1912 when the fire engine was housed in a building to the front. To the right is The Grange, the home of Dr Hulbert whose son, Jack, was a well-known comedy actor. In about 1940 the house became the Grange Maternity Home which closed in March 1979, since then it has been part of the headquarters of East Cambridgeshire District Council. Almost hidden in the trees, is the Holy Trinity vicarage where the police station now stands.

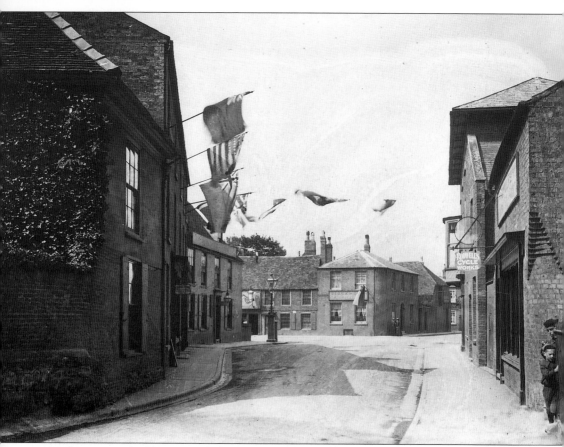

Looking towards the Lamb Corner from Minster Place, 1919. On the left is the Greyhound with, next door, a temperance hotel which in 1923 was replaced by Lloyd's bank. Opposite was a cycle works and garage. Across St Mary's Street, in 1920 was C.H. Gimbert, on the corner, and T. Coates who sold tobacco, both wholesale and retail, walking sticks and many other items. On the site, before and after the Greyhound, there were wine and spirit merchants, and there were wine vaults where the Minster Tavern is now.

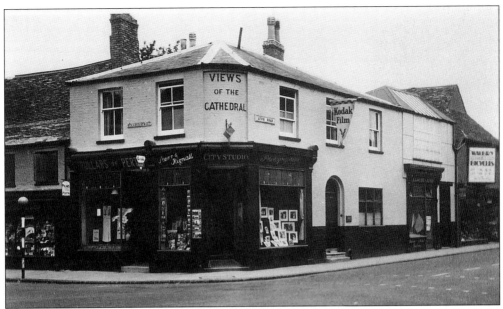

This corner has been associated with the visual arts for along time. In 1923 Starr and Rignall, moved into these premises, in the 1950s John Slater of Newmarket, followed by Jack Casselden, all men were photographers. After Mr Casselden's retirement in the 1980s a 'joke shop' occupied the premises for a short time before it became known as the Ely Art Gallery or 'Artist's Corner', a self-explanatory name, in September 1993. A part of the Walbro premises is to the right.

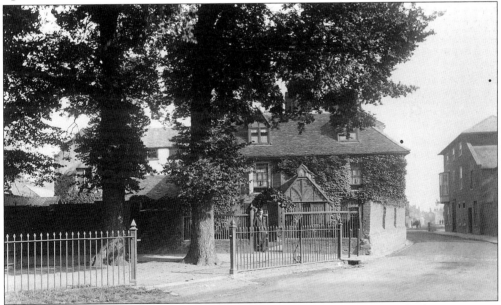

Cambridgeshire County Council's Ely branch library opened in new purpose-built premises, on the site of this house, 5 April 1966. In the early eighteenth century Thomas Kempton organist of Ely Cathedral and composer of church music lived here. In the 1920s G.H. Tyndall lived here but in the mid-1930s the Minster Tea House run by Vernon Cross, the Forehill baker, opened. It closed sometime around 1941.

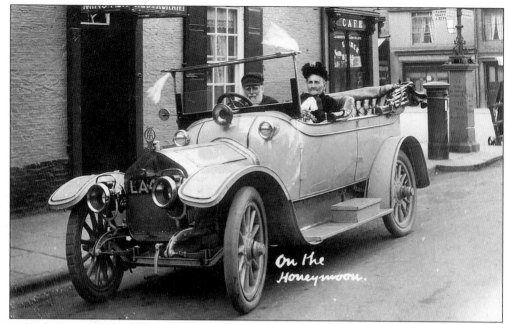

A Little Downham couple outside the Minster Restaurant and Cafe on 1 April 1914. This photograph was taken after their wedding, a second one in each case; Mr Lythell was eighty-four and his wife seventy-eight. The sign post next to the pillarbox was still upright.

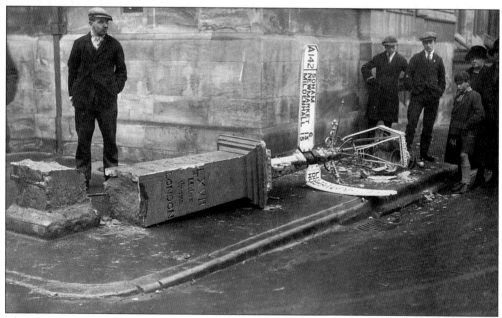

This was a busy junction where the roads from Cambridge, King's Lynn and Newmarket met the High Street, which can also be seen in the picture opposite. It is perhaps not surprising then that the substantial signpost was eventually knocked down by a lorry sometime between the late 1920s and early 1930s.

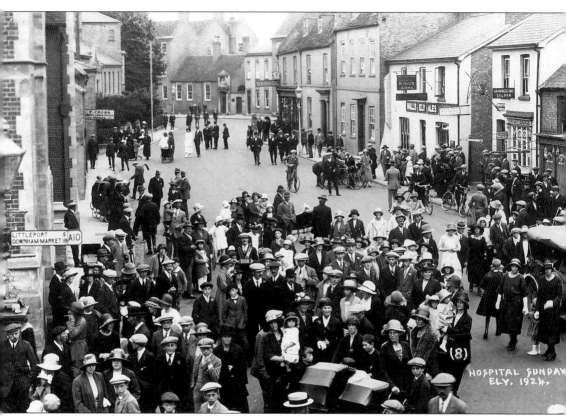

A typical Tom Bolton view of part of the Hospital Sunday Parade, 1924. The signpost with the lamp on top can be seen on the corner by the newly built Lloyds bank. In the centre background Bedford House can be seen, with the garage of Cass & Co. next to two private houses, one of which became the electricity showroom and is now a Black Horse Agency, and the King's Arms still open after over one hundred and seventy years. It is said that 'The last reputed witch burnt at Ely came out of a house upon the site of which the King's Arms is built.' To its right a hairdressing salon next to which was H. Bickley, tailor, to be followed by Olive Coates in the 1930s and most of the 40s and then Elsie Bender; both were ladies dress shops. Here, after several changes, Dominique's Restaurant opened in May 1990.

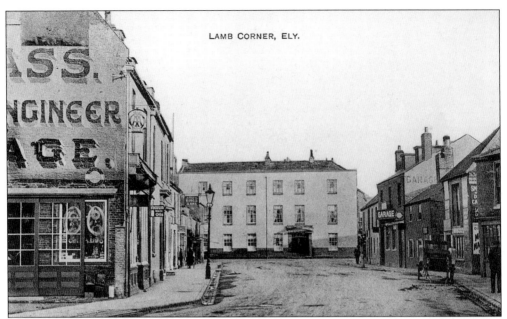

Looking east toward the Lamb Hotel. Alec Cass opened his garage sometime around 1914 on a site occupied by G.L. Woolnough, grocer, before that business moved to the corner of Downham Road around 1896. Opposite, a horseless carriage stands outside the smithy but clearly the motor car has taken over.

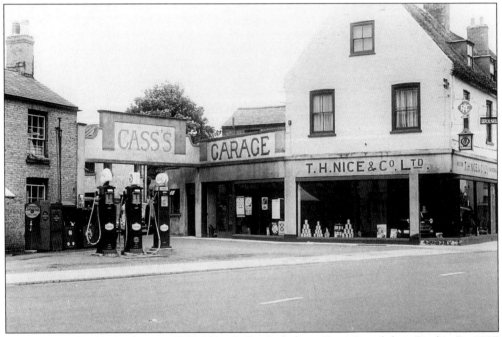

Cass's garage. By 1940 it became T.H. Nice & Co. Ltd., later Cowie's and then Birch's. By 1997 all had changed and Hereward Housing Association won a Civic Trust Award for the conversion of the whole of this corner block to houses. Two small houses further to the left of this view were restored by Ely Preservation Trust in 1980.

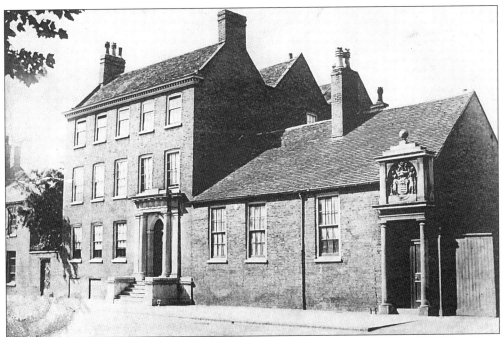

The single storey Fen Office with the main Bedford House to its left. It is shown as it was prior to 1905 when the grand entrance (the doorway though not the steps) was moved to the left where the gate to the garden had been previously. Bedford House, built sometime around 1800 by Thomas Page, was a private house except between 1824 and 1844 when it was the Bedford Level Corporation headquarters. It was sold to Cambridgeshire County Council in 1903. Ely High School occupied the building from 1905 to 1957 and it continued to be used as a place of education until 1988. It now provides a day centre for the elderly with a number of flats above.

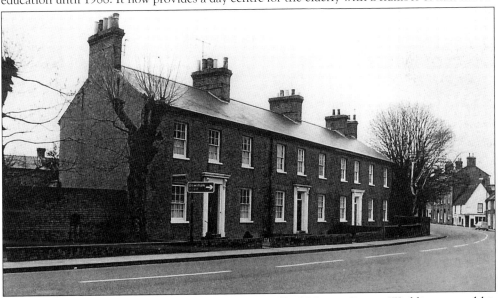

Waddington Terrace on the south side opposite Bedford House. Canon Waddington and his family lived in The Chantry to the rear of the terrace at the end of the eighteenth century when the property extended to St Mary's Street.

Opposite Oliver Cromwell's house in St Mary's Street is a handsome house, which was once the Guildhall. It was here that members of Ely's medieval guilds met. These were not craft guilds but existed mainly to provide candles to be used in church and also to dispense a small amount of charity to the poor.

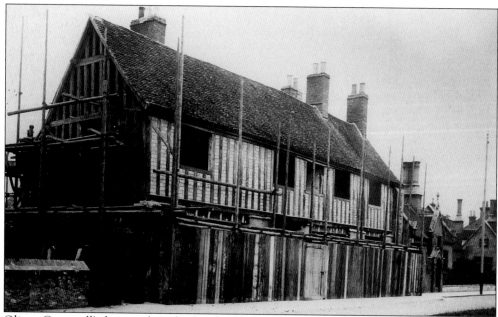

Oliver Cromwell's house where he lived with his family for about five years from 1636, his family probably lived there longer. After the lease passed through various hands the property was sold to Joseph Rushbrook in 1843, who opened 'The Cromwell Arms' inn. It again became a private house in 1871 and then in 1905 became St Mary's vicarage, which it remained until 1988. It is now Ely's tourist information centre which opened in November 1990.

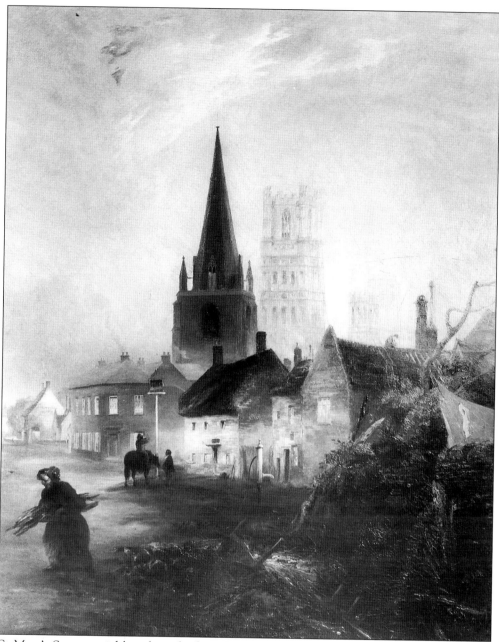

St Mary's Street; a richly coloured oil painting by Henry Baines, 1857. St Mary's fourteenth century spire looms over Sextry House and the former White Lion both on opposite corners of Silver Street. Thomas Parson's almshouses and the Cromwell Arms are beyond Sextry House.

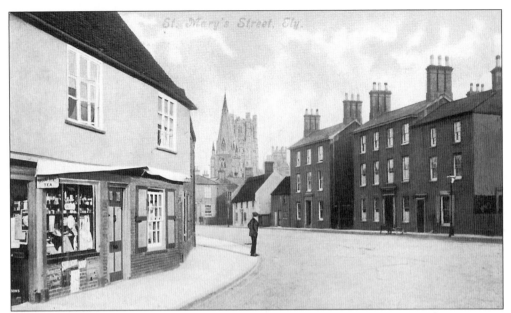

Similar to the previous picture in many respects the south side is dominated by the group of houses. In 1940 the three-storey house furthest from the camera was occupied by Dr K.S. Maurice Smith, number 37, previously the home of Miss Townley, was occupied by wartime evacuees and number 39 by Mrs Steele. Beyond this was number 41, the home of the Evans family who were Ely solicitors for many years. St Mary's health centre now occupies the site of number 37 and perhaps part of number 39.

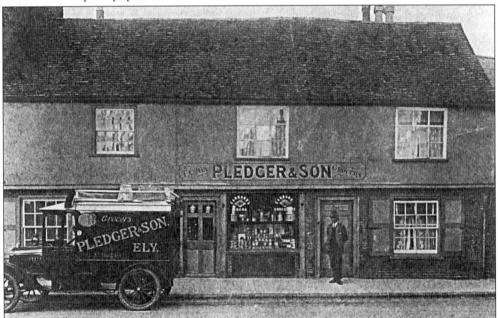

The shop on the left of the previous picture was kept by Miss Nixon between 1905 to 1922, Pledger & Son between 1922 to 1925, J.W. Throssel, J.E. Lloyd from 1936 until 1957 and then, Chivers & Caple. All traders were grocers and were followed by Yokels bookshop between 1979 and 1983. The shop is now occupied by Snipets hairdressers.

The view up Cambridge Road, known at one time as Bugg's Hill, from the junction with West End. Croylands, the large house on the right had originally been built as St Mary's vicarage. Little else has been built on the west side of the road which, without parked cars, looks much wider than it does today.

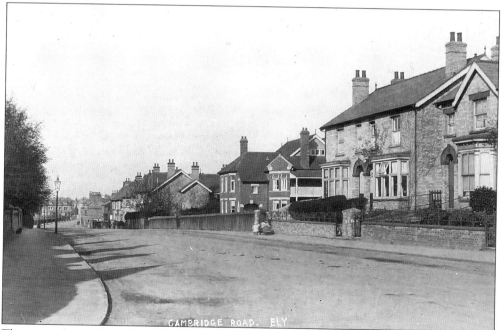

The view down the hill with much nineteenth-century building on the right. The large detached house was built sometime around 1909 for Davison's, draper, and was nicknamed 'Calico mansion'.

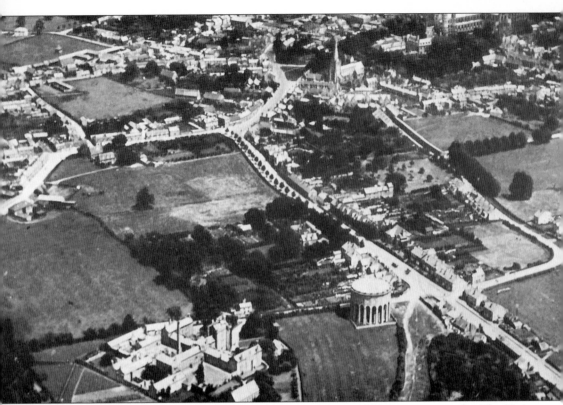

An aerial view showing, in the foreground, the prominent 1843 water tower, also The Union built in 1837 to accommodate three hundred and forty people, c. 1925. Opposite the water tower Barton Road, in the mid-nineteenth century known as Smock or Smockmill Alley, turns to the right. Cambridge Road, with a fine row of trees, meets St Mary's Street where a garden, which stretched along to St John's Farm, is on the corner. At the time this photograph was taken the 'bus depot had not yet been built.

Three
High Street and Back

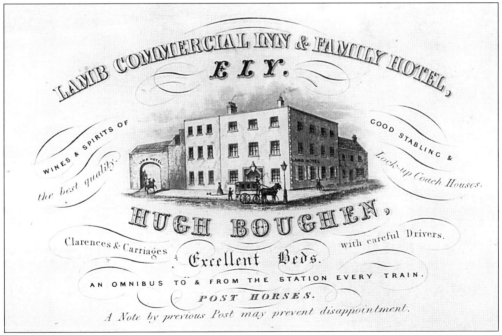

The Lamb Hotel. A bill head from the period when Hugh Boughen was landlord during the 1850s, which not only lists all the advantages the hotel can offer but also accurately depicts its appearance both then and now. The history of the hotel goes back to 1416 or earlier when it went by the name of 'Agnus Dei', the Lamb of God, a traditional name for an inn near to a monastery. With the growth of the Turnpike Roads in the eighteenth century The Lamb became a posting house for stage coaches.

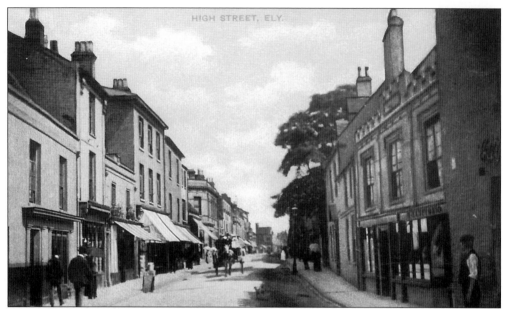

High Street viewed from the Lamb Corner, *c.* 1908. The tall house and shop on the left is that of J.A. Gardiner, chemist, with, next to it, Legge's shoe shop, then Pledger's, drapers, and Cutlack's, ironmongers. The present Bonnet's baker's shop and cafe was at this time the Capital and Counties' bank, later Lloyd's Bank Ltd. On the opposite side is A.E. Kempton, tailor, and then St Audrey's, Dr F.H. Beckett's house and surgery.

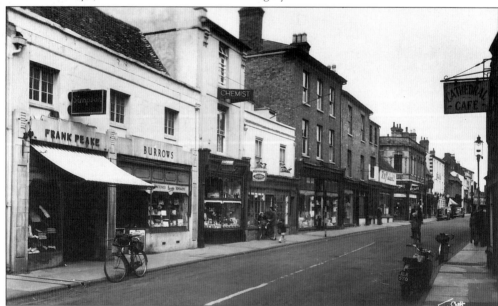

Almost the same view as the previous photograph but perhaps about fifty years or more later, with the Cathedal Cafe on the right. Burrows has a new shop front and Gardiner's, later occupied by Ely Electrical Services, Legge's and Pledger's are still open. The latter was followed by Lipton's in the 1970s and is now Argos. One of the few, later first floor changes on the north side of the street is that the sash windows above the electricity shop have been replaced with smaller ones.

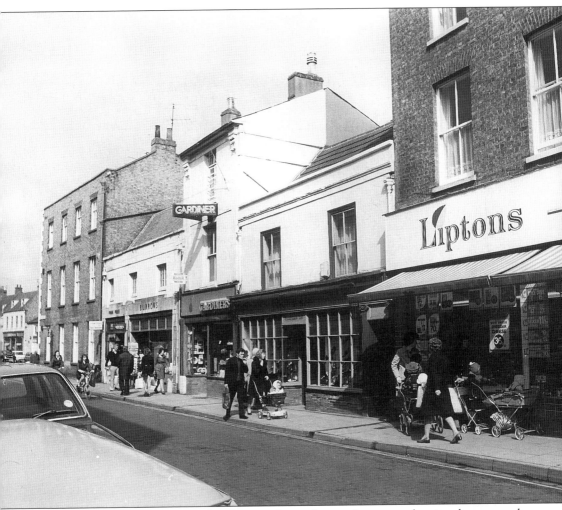

A view virtually unchanged from the photographs on the previous page, showing shops owned by Frank Peake, Burrows, Gardiner's and Legge's, *c*. 1972. Lipton's grocery store have moved into Pledgers where the firm remained throughout the 1960s.

The trees in this view looking toward Lloyd's Bank are in the garden of St Audrey's. In 1935 the premises from the left were Barclay's Bank, Russell Wright, butcher, J.P. Tibbits, printer and stationer, Miss Sandell, the Craft Shoe Co., Miss Snell, florist, Frank E. King and, on the other side of Steeple Gate, Madam Berkell, hairdresser. Russell Wright's shop was burnt down in the late 1930s but his shop soon re-opened on the other side of the street, next to Bonnet's. On the right is the hanging sign of the Bell Hotel.

By 1936 the properties had been replaced by Coronation Parade, the ground floor of which was occupied by shops, the largest of which was Peacock's stores and part of the upper floors by the offices of the Inland Revenue.

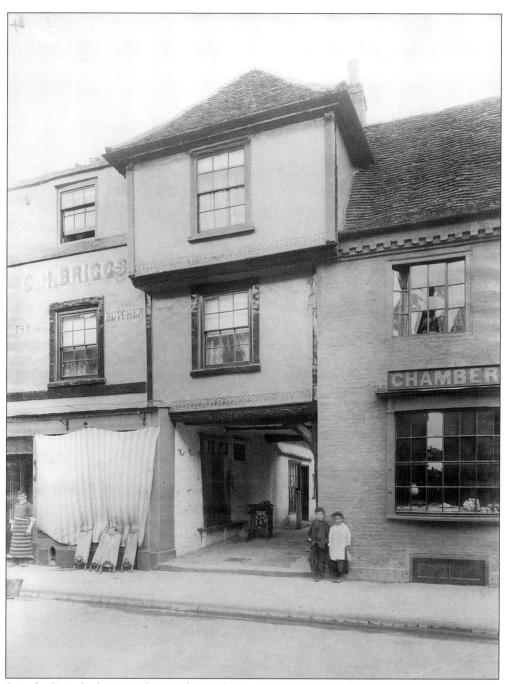

Steeple Gate, looking much as it does today, *c.* 1900. The part of the gate above the archway may date from around 1500 but the brick vaulted undercroft is fourteenth century; an earlier building on this site was known as St Peter's Tower. C.H. Briggs was a noted butcher, 'better pies never were nor could ever be made'. Peter Chambers, pork butcher, occupied the shop later to be Crawley's and now part of the Trustee Savings Bank.

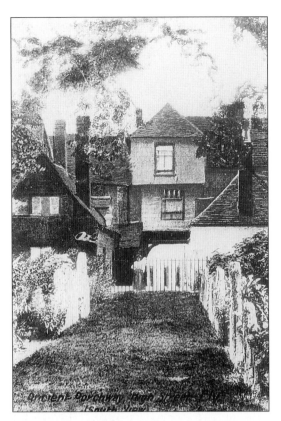

Ancient Porchway from St Cross, Ely (South View)

Steeple Gate viewed from the churchyard of St Cross. The burial ground ceased to be used in about 1855 when a new cemetery was opened off New Barns Avenue, then almost on the outskirts of the city. The lean-to church of St Cross built onto the north side of the cathedral was demolished in 1566 when the parish, then with the name of Holy Trinity, was granted the use of the Lady Chapel. In 1938 the parishes of Holy Trinity and St Mary's united to form the Parish of Ely and so the Lady Chapel returned to the care of the Dean and Chapter.

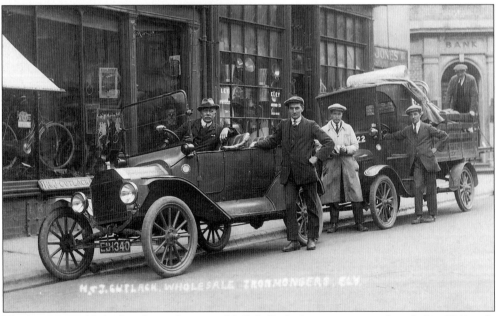

The longest established trader in the city is H. & J. Cutlack, ironmongers, founded in 1841 only a few years before Peck's. The younger of the two men by the car is Frank Clarke who managed the business for many years.

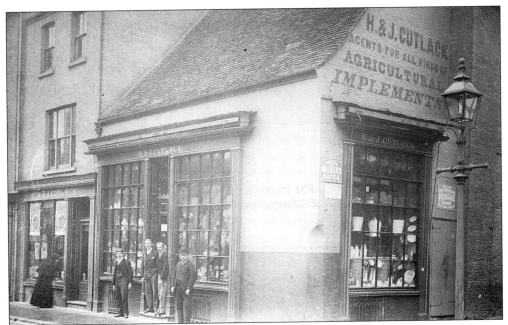

H. & J. Cutlack in 1900. This front part of the shop was only recently demolished in 1990, to make way first for Freeman Hardy and Willis' shoe shop, one of a few businesses which went back to the nineteenth century in the city. These premises are now occupied by Hush Puppies while Cutlack's continues trading in premises that go through into Market Street.

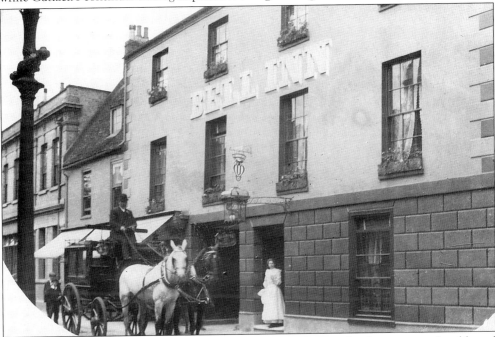

The Bell Hotel. Less pretentious than The Lamb this hotel was said to be more comfortable and cosy; it could also offer a horse-drawn omnibus to meet every train. Since the hotel closed in 1959 various stores have since used the premises from the International to the present Lloyd's, chemists.

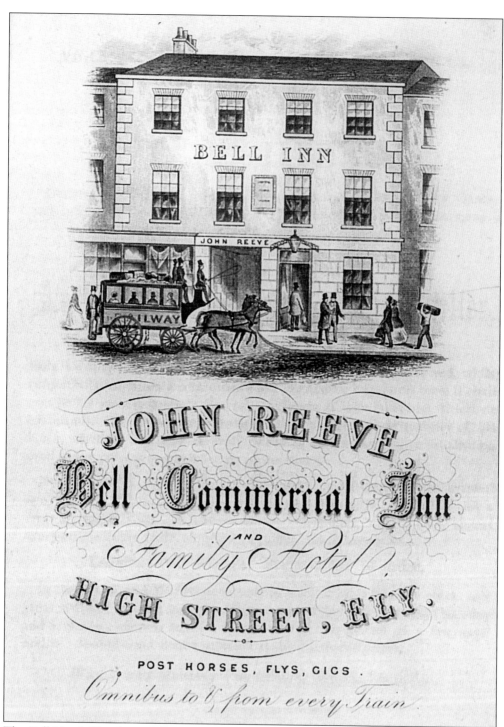

BELL INN

JOHN REEVE

ILWAY

JOHN REEVE
Bell Commercial Inn
AND
Family Hotel,
HIGH STREET, ELY.

POST HORSES, FLYS, GIGS.
Omnibus to & from every Train

The Bell Hotel. This beautifully presented small advertisement was published, as was the bill head seen at number 50, in a 'handbook to the cathedral church of Ely; with engravings' published in Ely by T. A. Hills, bookseller. From 1852 this small booklet, probably written by Mr Hill as no author is mentioned, ran to many editions; this advertisement dates from 1853.

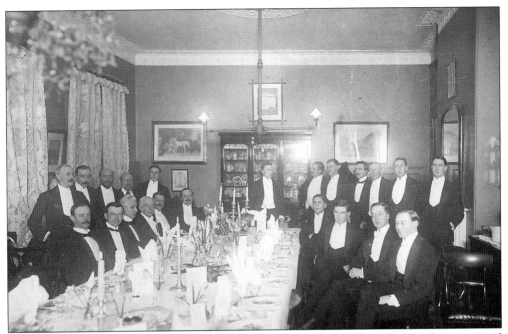

Dinner at The Bell, *c.* 1920. Standing third from the left is Arthur Deer Pledger, draper, second from the left, seated, Owen Ambrose, farmer, third from the left Thomas Walton Blakeman, currier and leather merchant with William Hawkes, coal merchant next to him. On the other side standing fourth from the right at the back is Thomas William Blakeman and somewhere in the photograph is Billy Luddington and William Lincolne, chemist.

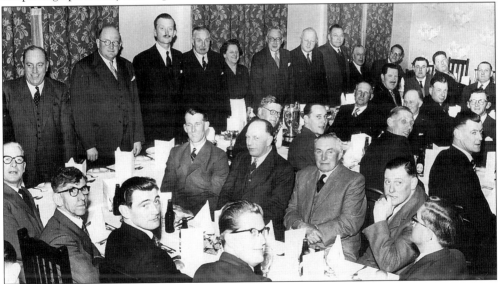

A Conservative Club dinner at The Bell, March 1957. Back row, left to right: Bill Evans, George Comins, Sir Harry Legge-Burke, MP, Mr Cutlack, waitress Daisy Rogers, Reg Houghton, Eric Aveling. Seated, near the camera, are: Bill Nicholas, Mr Butler, postmaster, Michael Mynott. Also in the picture Graham Fisher, Ernie Chambers, John and Tom Morton and Les Cornwall. Sir Harry was the member for the Isle of Ely for twenty-eight years during the period when the Isle had separate Parliamentary representation.

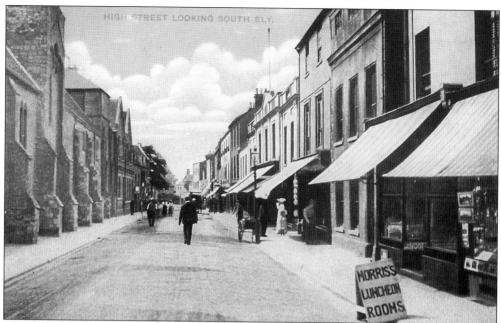

High Street looking west. Barclay's Bank, the building with the two gables, is seen on the left beyond the Bell Tower, once used by the Holy Trinity Parish. Morris's Luncheon Room and in the 1920s Morris's Bazaar, pre-dated Lincolne's and then Boots, both chemists. Morris's was said to be 'one of the most attractive shops in Ely, its pastries were of a quality unequalled.'

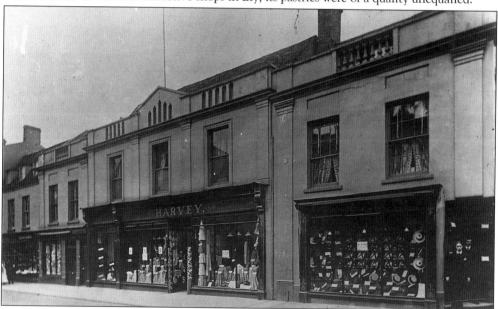

J.M. Harvey had taken over George Tunkiss' premises (previously Butcher & Bard) in 1893 and soon occupied a considerable length of the street from the Bell Hotel to High Street Passage, providing departments which sold furnishing fabrics (now Travel World), children's clothes and ladies underwear (Sue Ryder shop), ladies fashions (later Boots now United News) and gentlemen' tailoring (Mayfair now Oxfam) on the corner of High Street Passage. The business had closed by 1956.

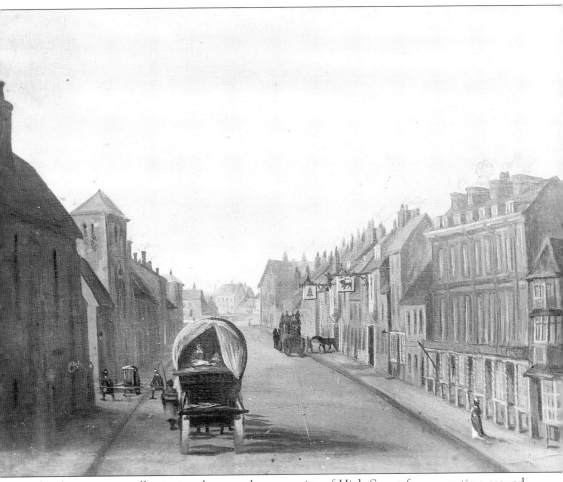

This fascinating small painting, by an unknown artist, of High Street from sometime around 1840 shows on the south side a sedan chair probably containing the Dean's wife, who is about to be carried through Church Way near the Bell Tower. (The Sacrist Gate archway was filled in at the time and was part of the verger's house). In the distance is Bedford House and on the right the Lamb Hotel, the Bell Hotel which took its name from the tower, the Red Lion public house and near to the viewer an extraordinary bay window removed from the facade of Peck's shop, probably in the 1920s.

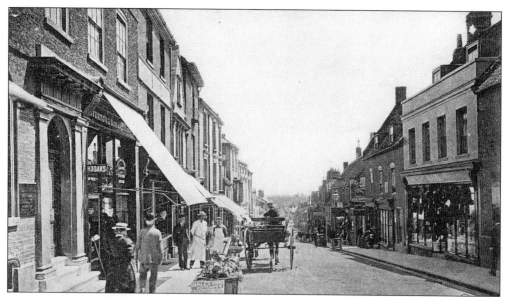

A busy scene looking down Fore Hill from the Market Place, *c.* 1905. Sturton and Howard's chemists are on the left with the steps that once led up to the front door of the adjoining house and Eastman's, butchers. Opposite was the shop that later became Morriss's, now Rite Price, and below it a sewing machine depot.

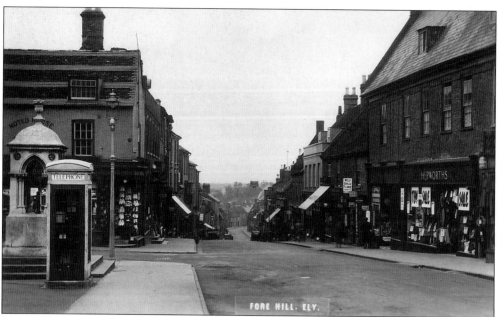

Fore Hill looking down to Waterside. The red telephone box partly hides the fountain on the corner of the Market Place. Haylock's shoe shop, on the corner from about 1858 to about 1984 was, during the seventeenth century, the Duke of York public house, and opposite Hepworth's, was once the Three Cups public house.

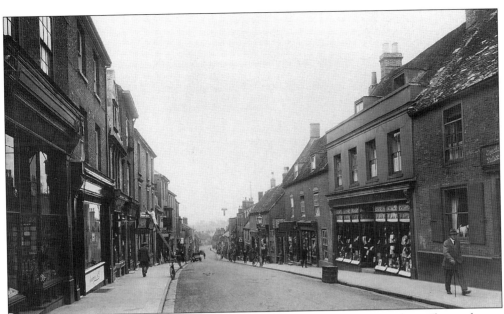

Fore Hill. This is a similar view to the previous photograph but of a later date. The road is no longer cluttered with various objects because the motor car has arrived. On the right are the premises of Mr Goodin, tailor, next to Morris's clothiers, while further down the road, the word Taylor painted high on the wall marks Joshua Taylor's premises and Cross's now has a prominent 'Ye Olde Rooms' sign high above the street.

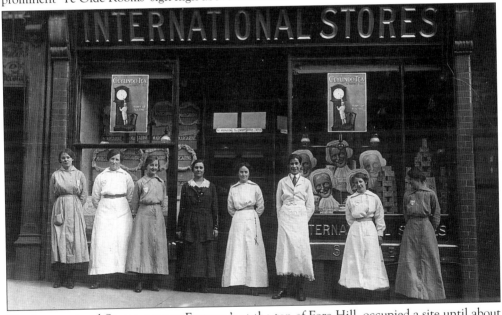

The International Stores, next to Eastman's at the top of Fore Hill, occupied a site until about 1901 where the Conservative Club opened a few years later. The business then moved further up Fore Hill before going to High Street where the Home and Colonial Stores had been (now Barrie's). A further move took the firm to the other end of High Street where Lloyd's is now. Second from the left is Elsie Dunthorne, also photographed are: ? Ablett, Willy Woods, Daisy Rogers.

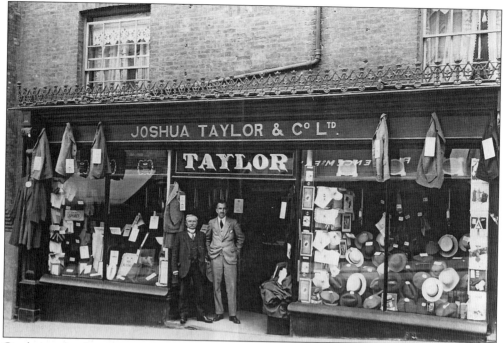

On the south side premises, now between the Royal Standard and Toppers, was Joshua Taylor's, 'tailors, clothiers, woollen drapers, hatters, hosiers and general outfitters' established in 1851. This was the firm later to become a well-known Cambridge store. Mr A. Hamence, who had been with the firm for sixty years, stands with Mr E.R. Taylor in the doorway on 30 June 1930.

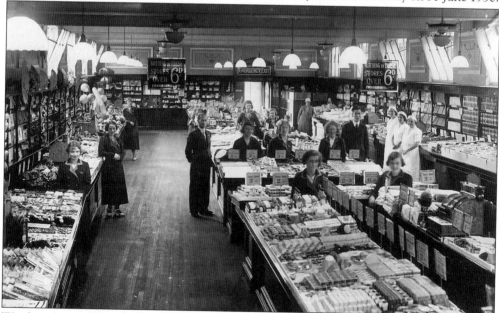

Woolworth's, shown still on its original site. The 3d and 6d store, sold nothing over sixpence (2.5p) when it opened sometime around 1935. It had nearly twenty staff and a wide variety of goods from china, some of which is now quite collectable, to make-up, sweets, biscuits, hardware and haberdashery.

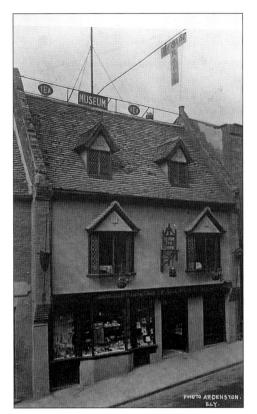

Ye Olde Tea Rooms opened by F.T. Cross at the end of the nineteenth century and continued by his son Vernon who had a varied collection of, mostly local, objects on display in his restaurant/museum. He was a onetime President of the National Association of Master Bakers, an entertainer and local councillor; one of the city's characters. The private museum was sold in 1964 on Vernon's retirement and the building, which may date to 1553 or earlier, became part of the adjoining Royal Standard in 1969.

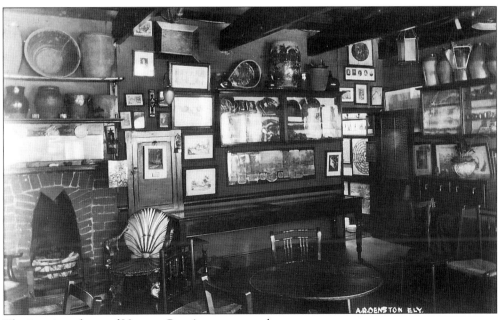

The interior of part of Vernon Cross's museum and tea room.

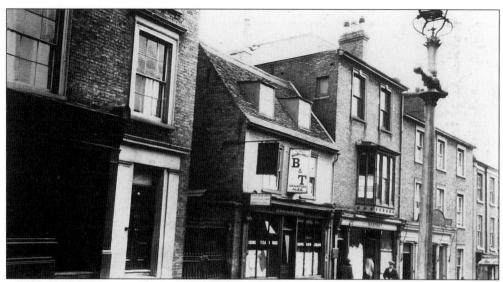

The north side of Fore Hill. Since this photograph was taken in the 1920s very few changes can be found above ground level between the Market Place and the site of the brewery buildings near the bottom of the hill. The Baron of Beef public house has given way to a new building, now J.M. Evans, mens' outfitters. Next door is now occupied by Artspace and beyond, where Rayment's butchers shop was, Mr Milwright has his veterinary practice and home. Below was Blake's furnishers after a move up the hill from the premises now used by Petal Foods; this came after an earlier move from Broad Street.

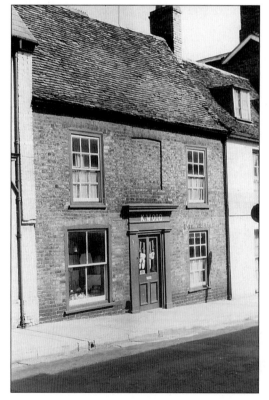

This small shop between the Conservative Club and a private house was kept by Miss Kate Wood, a small brown faced lady who always wore a tweed skirt, a jumper (it was not known as a sweater in those days) and a round faded green hat with a small brim. She sold haberdashery and hats, a mixture of old and new items. During World War Two she sold newly laid eggs, brought in by a lady who travelled into Ely by train on market days.

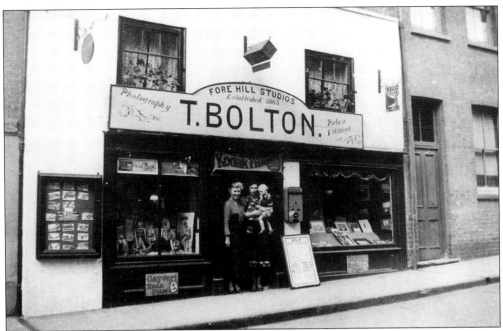

Tom Bolton. The Bolton family had been photographers in Ely since 1863 and continued until Tom's death in 1943. During a period of over forty years Thomas Samuel Bolton faithfully and meticulously recorded daily life in the city whether it was floods or processions or some other event. His photographs are particularly valuable as a resource because he often put the day, month and year with a note of the place or event on the front of his photos. The board outside advertises the films showing at the Rex cinema.

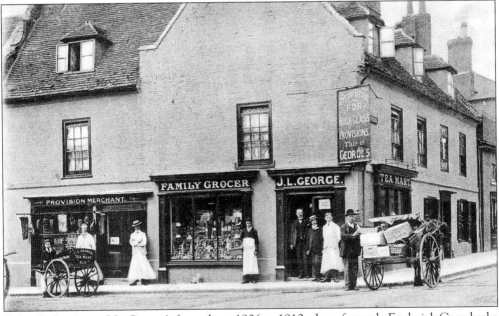

Below Bolton's was J.L. George's from about 1906 to 1910 where formerly Frederick Cope had a tea, coffee and spice warehouse. Later A.C. Lemmon, butchers occupied the site for many years, owned in the nineteenth century by William Rusbrook.

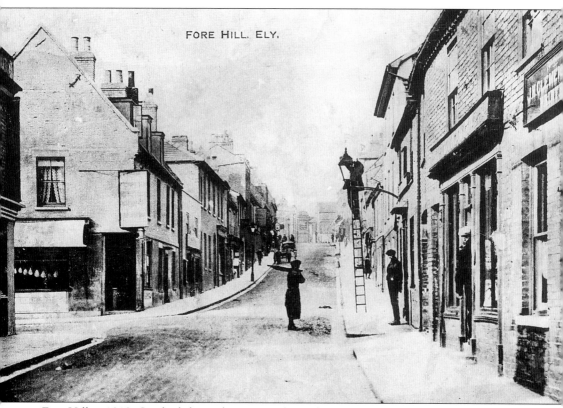

Fore Hill, c. 1912. On the left, on the corner of Broad Street is the Glazier's Arms which closed in 1969 and was subsequently demolished. Opposite, A.C. Lemmon has taken over George's premises, an area now mostly open space between the two wings of the office block. Looking up the hill the small building is Bolton's studio, T. Blakeman & Son, leather merchants and curriers, C. Wood, fruiterer, Mrs Bolton, art depot, the Rose & Crown, J.G. Benson, baker, J. Pryor, bootmaker and the Royal Standard. On the other side is Clements, printers (the building now surrounded by houses built in 1996), then L. King, boot and shoe repairer. Slightly set back and so not seen in this photograph the 'Round of Beef' public house, now demolished.

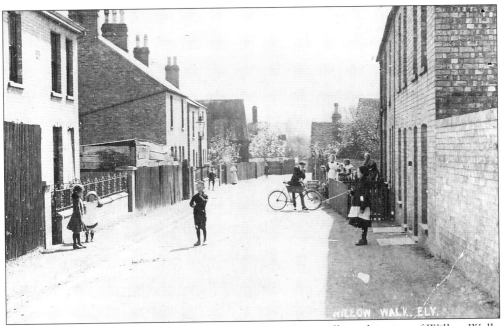

Go to the bottom of Fore Hill, turn left, then right and you will see this view of Willow Walk. It is no longer so run down and new houses replace Lemmon's old slaughter house on the left.

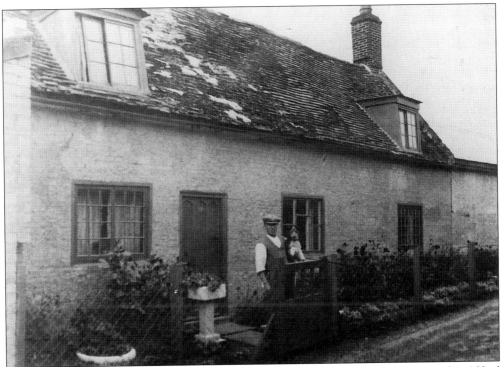

Go further and you would, some years ago, have found this small cottage on your right. Alfred Newman and his dog, Spot, are pictured here at the door.

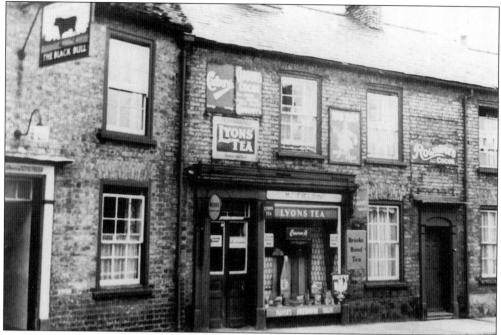

The Black Bull was in Waterside from the seventeenth century to 1985. Next to it, where Ely Chandlery is now, was the general stores kept by Monty Fielding, one time footman and in the First World War a member of the Medical Corps; he was wounded under fire and awarded the Military Medal. On the front can be seen six enamelled advertisement 'boards', now museum pieces.

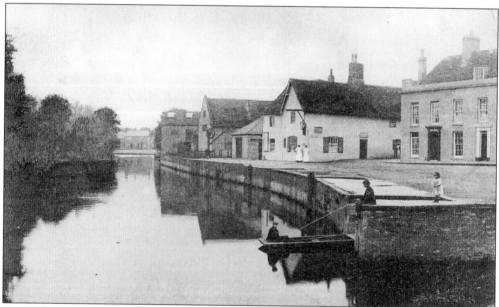

Quayside, c. 1905. The group of buildings in the middle distance including the later much altered Ship Inn was demolished to make way for the Riverside Walk opened in 1968. Ely Maltings (built in 1868), behind the Ship was converted into a public hall, opened in 1971, after Watney Mann sold to the local council for £100.

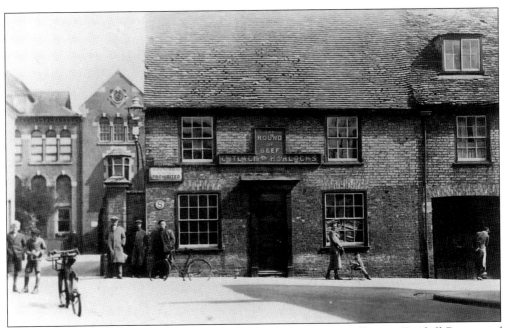

Broad Street in 1902. The Round of Beef stands next to Henry Hall's new Forehill Brewery of 1871. In 1930 A. & B. Hall Ltd and Cutlack & Harlock Ltd amalgamated to form Hall, Cutlack & Harlock Ltd and all brewing was transferred to the Forehill Brewery.

The Forehill Brewery shortly before its demolition in the 1970s. On the left is Mrs Jones' sweet shop, on the right the Glaziers Arms.

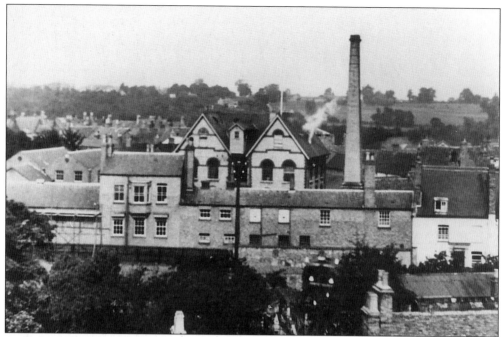

Cutlack and Harlock's Quay Brewery, Hythe Lane, c. 1929. At the beginning of the Second World War, in a cellar to the left of the section demolished to make an entrance to the then Tesco car park (Tesco moved in 1994 to a site near the station) was a public air raid shelter. The section above the cellar can be seen on the left and, unlike the tall chimney and most of the other buildings, can still be seen.

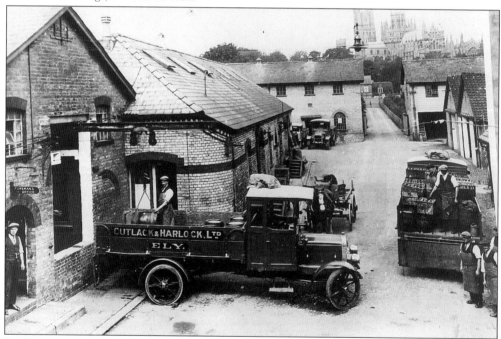

Looking towards Broad Street the same brewery in the early 1920s. From left to right: Walter Chevill, Harry Bidwell, with barrel hoist, Bryant, Joe Jones and Ted Barret, horse-keeper.

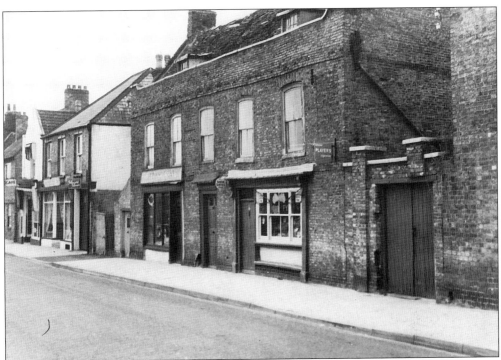

Broad Street, April 1962. Many locals will remember the shop on the right as Richardson's green grocery but in 1908 it was H. Lemmon, poultry and A. Lemmon, butcher; by 1920 only poultry was sold. G. R. Martin had the premises in the 1930s and continued to sell poultry and dairy produce. Beyond is A.V. Bonnet, baker, and the Kimberley hotel and cafe.

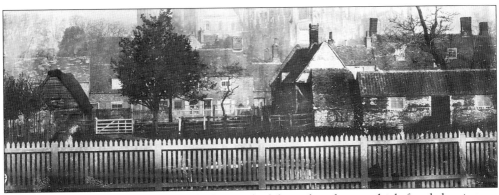

This view from Harlock's garden, which stretched from their house which faced the river to Broad Street, was probably taken sometime around 1900. The gable end of the Wheel public house is seen here to the right of centre. The house almost in the centre which once belonged to the Blake family has been considerably altered and modernised and part of the house to its right has been incorporated into a newer house.

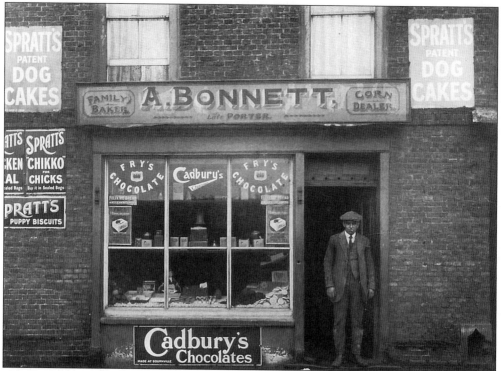

A.V. Bonnett, bakers. Mr. Bonnett stands at the door of their Broad Street shop; the same family firm are still bakers but now in the High Street.

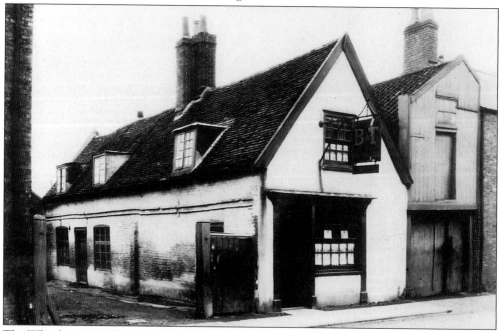

The Wheel in 1902. The second building beyond Harlock's garden on the east side of the street. This pub closed in the 1930s and was, for a short time a private house before it was demolished sometime around 1962. In 1982 a modern house was built on the site.

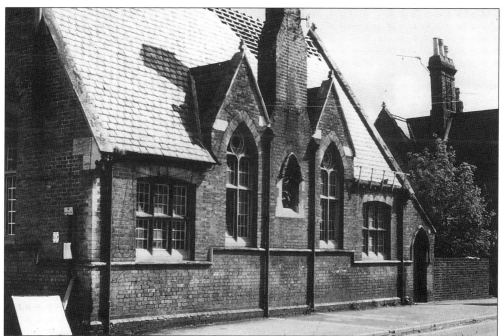

Broad Street School on the corner of Ship Lane was built in 1859 designed by Samuel Saunders Teulon who also designed the house next door which still stands. After use by various Ely schools until 1968 the building was converted to serve as Ely Pottery and was demolished after it was gutted by a fire in 1981. A stone carving set into the wall admonished pupils to 'OBEY THEM THAT HAVE RULE OVER YOU'.

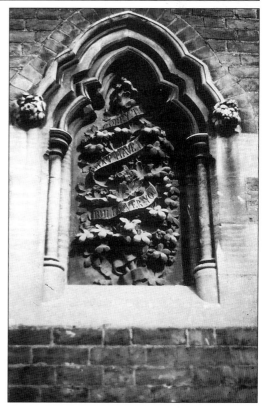

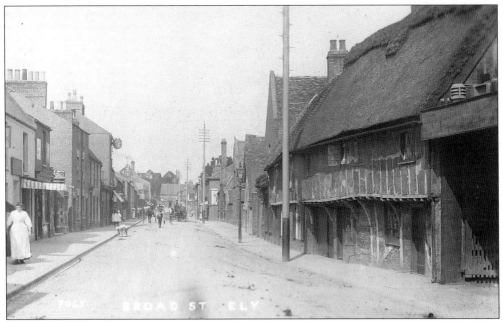

A short distance away on the same side of Broad Street, almost opposite to the entrance to The Park, was once this row of timbered jettied cottages which were demolished in the 1930s so that the entrance to the wood yard of A. Wood & Co. could be widened. In 1996 the wood yard, no longer Chapman's or Woods but Jewsons, moved to new premises in Angel Drove and the site was cleared. The Round of Beef stands centrally in the distance and smoke comes from the brewery chimney to the left.

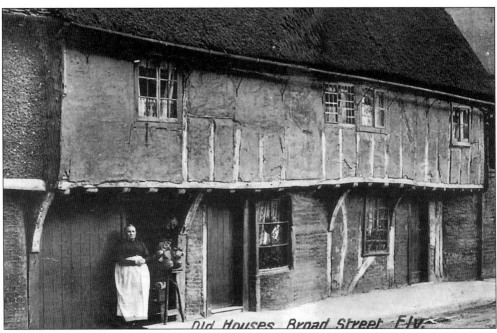

Two cottages, that on the left was occupied by J. Hardy, fell monger in 1908.

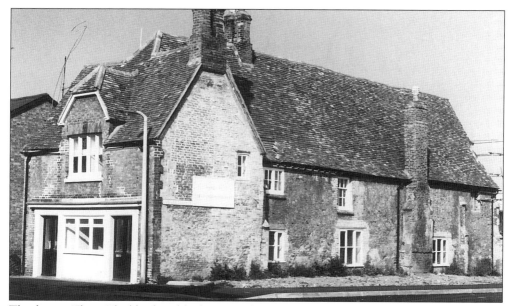

The former Three Blackbirds public house in the early 1980s before its restoration in 1984 and conversion into three dwellings by Ely Preservation Trust. Once a merchant's house, this is the largest medieval dwelling to survive in Ely outside the monastic area; the central part, dated by the smoke-blackened roof timbers above the one time hearth, goes back to around 1280. This building is a reminder that the main trading route, which linked Ely with Cambridge and King's Lynn until the nineteenth century, was the river.

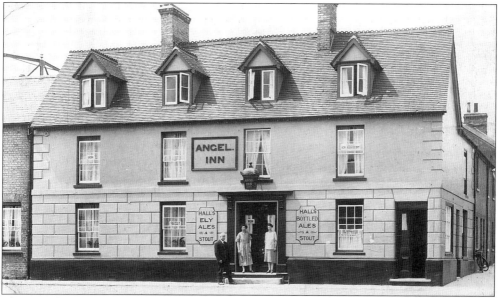

The Angel, Station Road, landlord Clarryvince Stedman with his wife and daughter stand at the door. The history of the Angel Inn goes back to the seventeenth century or earlier. After its closure in October 1995 the building, with The Angel tap to the right, was converted into offices for the firm International Research Consultants in 1997. The firm moved from the former Peacock public house in St Mary's Street and brought with it the sculpture by Roy Bell seen on the wall.

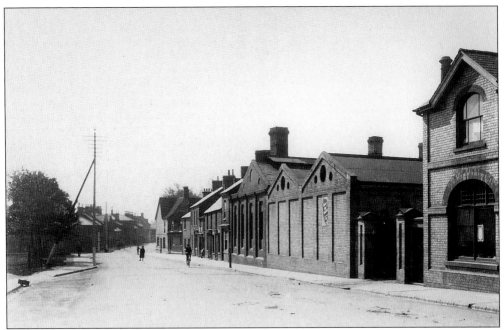

Ely Gasworks opened in 1835 so soon 'the darkness of the venerable city was changed into brilliant light'. Gas continued to be provided from the Station Road works until 1958, three years after the street lighting had been changed to electricity. A garage later occupied this site where in 1995 new houses, unlike any others in Ely, were built.

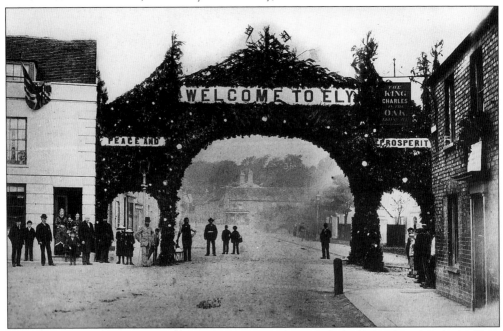

Welcome to the County Agricultural Show, 1887. The arch linked The Angel with the King Charles in the Oak, now part of Standen Engineering Ltd. The former Rifleman or Volunteer public house can be seen beyond. The boy second from the left wears Needham's School uniform.

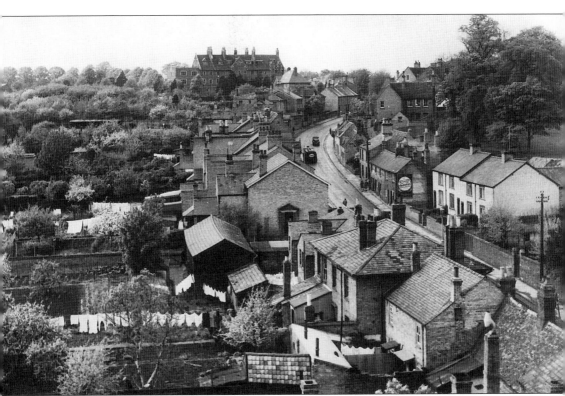

The view up Back Hill in 1956. Dominated by the former Theological College little has changed in forty years; the small cottages on the right have been replaced by houses. Beyond, a glimpse of the Needham's School building can be seen, which is now an arts centre for the King's School. Following Catherine Needham's will the school was built in 1740 and money was provided for boy's education and clothing. The school closed in 1969 and a resource and technology centre was housed there for almost twenty years; the technology unit continued for another five years.

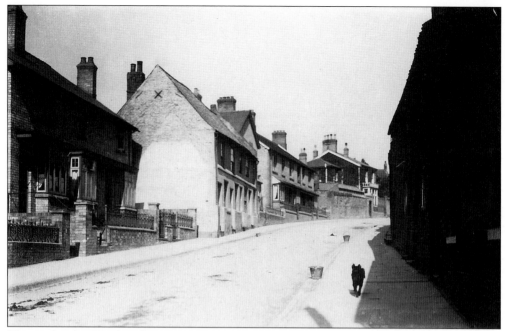

The south side of Back Hill in 1920. As in most streets in the city centre there was once a public house situated here; the White Horse. It dated back to the seventeenth century and was probably where the third block of houses from the left stand today.

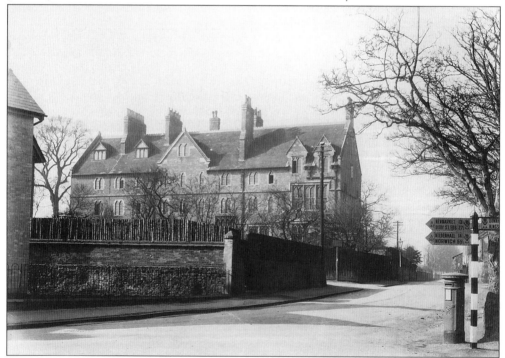

The Theological College in 1902. Founded in 1876 the students used this building from the time it was completed in 1881 until the college closed in 1994. It is now used by the King's School.

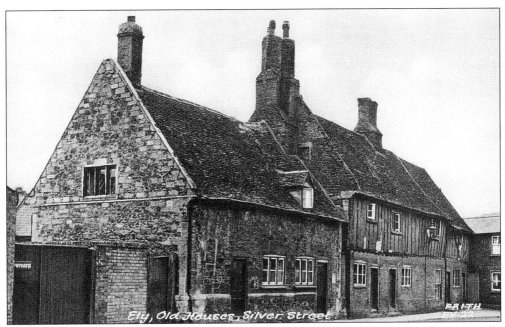

The three-timbered cottages in Silver Street, dating from sometime around 1400, originally jettied, formed one Wealdon type house. The house on the left has exciting paintings (fifteenth or sixteenth century) on the first floor which include a dove with the words *Deale Justlye*; this perhaps confirms the idea that it was a merchant's house. The central cottage has fourteenth century vine-scroll ornament on the ground floor .

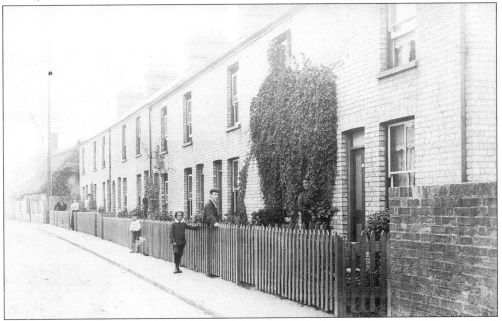

Parade Lane. This row of small cottages is in a lane which links Silver Street with Barton Road. The name perhaps reflects the use of this part of Ely by the Militia up to 1918; the Barracks Field was opposite. The thatched cottage was the home of Mr Ankin, chimney sweep, until sometime around 1961.

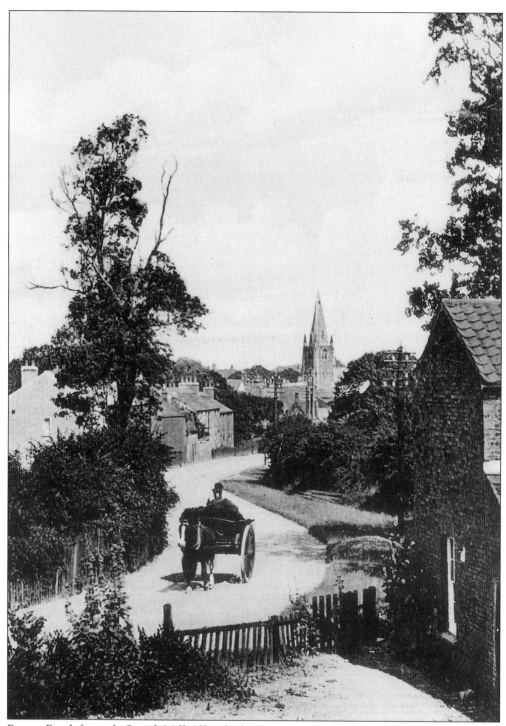

Barton Road, formerly Smock Mill Alley, looking towards St Mary's church, *c.* 1910. This view was taken from an early coloured postcard published by J.F. Burrows. An annual 'Green Book', *Best and Brightest Ely Almanac*, was also published by Burrows early in the twentieth century in rivalry with the City of Ely 'Red Books' published from 1893 by Tibbitts and later by Jefferson's.

Four
Homes and Gardens

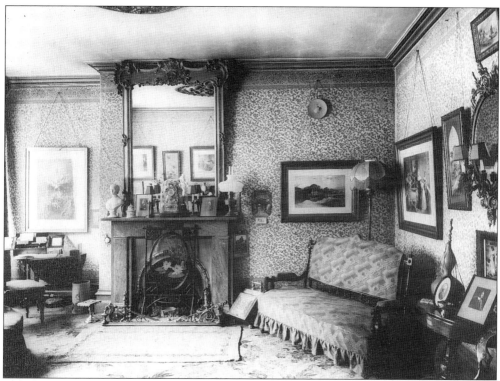

The drawing room at No.38 Fore Hill, Ely. Although the photograph was taken sometime around 1940, the room is shown as it may have been for many years and probably still contained many wedding presents given when Mary Ann Hall, daughter of the butcher almost opposite, married Thomas Walton Blakeman in 1881. Perhaps a somewhat pretentious room for a currier and leather merchant but he no doubt wanted to 'keep up with the Jones!' The house was built in 1867 and demolished in 1973; an office block is now on the site.

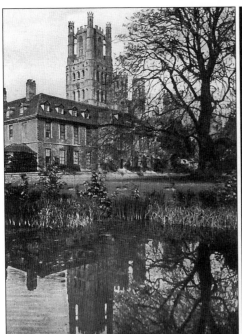 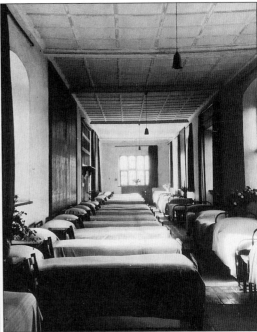

Left: The Bishop's Palace, no doubt the grandest residence in Ely when it was used by the bishops from the fifteenth century to the 1940s. It is seen here from the garden with the west tower of the cathedral reflected in the pond. On the right is part of the largest oriental plane tree in the country said to have been planted in the seventeenth century by Bishop Gunning. The building, after it was used as a convalescent home for servicemen during the Second World War, housed a Red Cross School for physically disabled children and is now a Sue Ryder Home. *Right:* During the Second World War there were rows of beds along each side of the Long Gallery.

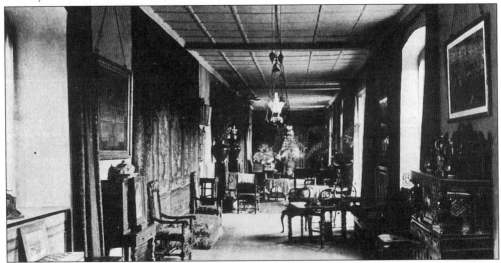

The Bishops Palace showing the Long Gallery built in the sixteenth century by Bishop Goodrich. This postcard dates from sometime after 1902 so it probably shows furniture belonging to either Bishop Alwynne Compton, Bishop Henry Chase or Bishop White-Thompson.

Two rather grand ladies and a gentleman in the garden, probably at the back of Sextry House on the corner of Silver Street, *c.* 1910.

Tradesmen sometimes lived in quite large houses; here Mrs Emma Granger sits in the garden of her home, Vineyard House. Granger's Fruit Preserving Company was opened in 1890 and continued to trade until the 1920s. The new factory premises built in 1909 eventually housed St Martin (Eastern) Ltd. who produced jams and marmalade. St Martin's Walk housing complex has occupied the factory site since 1987.

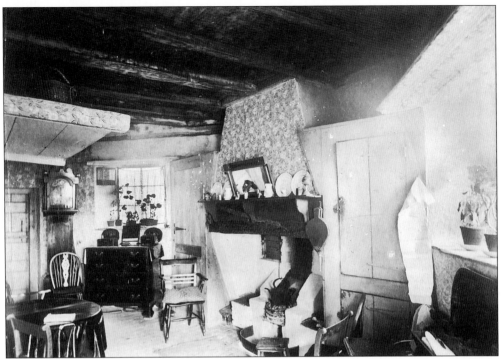

The Overfall Mill, *c.* 1900. The interior of a humble, but more homely dwelling; the living room at the Overfall Mill, Queen Adelaide Way.

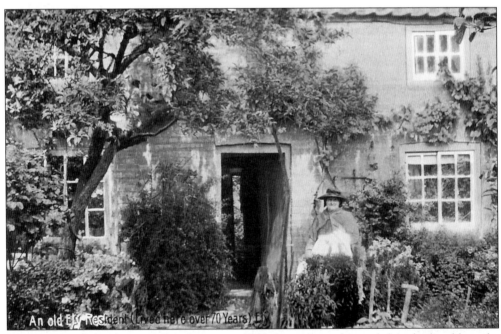

An old E[.] Resident (Lived here over 70 Years) E[.]

Mrs Day outside her home at Broadpieces, *c.* 1902. It states on the card that she lived here for over seventy years.

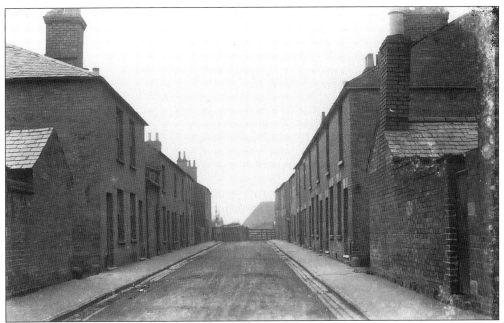

Small terraced houses in Bernard Street seen here from Chiefs Street in the 1920s.

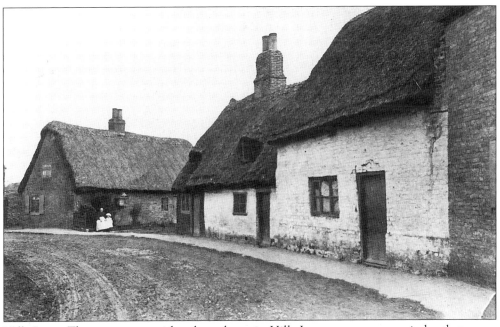

Hills Lane. These cottages, said to have been in Hills Lane, serve as a reminder that many properties in Ely were, at one time, thatched. The only old building still with a thatched roof is the barn at Waterloo House on West Fen Road.

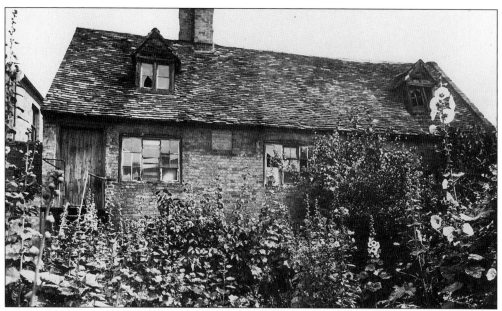

Ely Holy Trinity Workhouse. Not homely or comfortable, the workhouse stood behind the Round of Beef near the Forehill Brewery. The stone just under the eaves reads: 'W. Harlock, Jnr. H. Rance, Overseers 1811'. St Mary's Workhouse was on a site to the west of the entrance to the present St Mary's Court, where the Plough and Fleece and later the Kumin Café once stood.

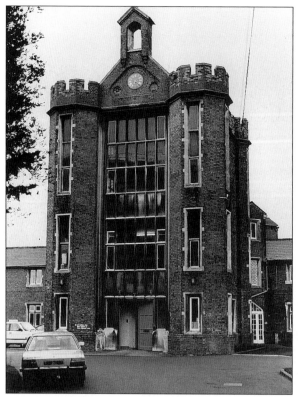

Ely Union Workhouse was built in 1836 to house three hundred and forty people and to replace the workhouses of both Holy Trinity and St Mary's parishes. The workhouse, known locally as the Spike, was a place to be avoided if possible; people said that they would rather die than go there! It eventually became a geriatric hospital and day centre known as Tower Hospital which closed in May 1993.

Five

Life and Death

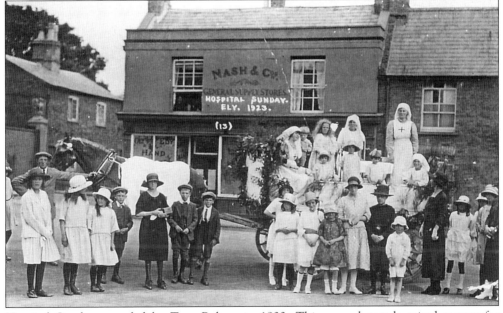

Hospital Sunday recorded by Tom Bolton in 1933. This annual parade raised money for Addenbrooke's Hospital in Cambridge and for a convalescent home at Hunstanton.

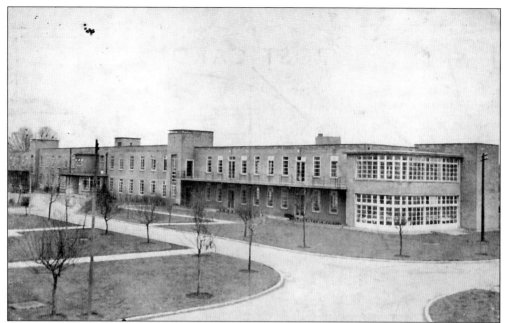

The Royal Air Force Hospital, Ely. The hospital later became known as The Princess of Wales R.A.F. Hospital after the Princess had paid a visit there before opening the Cathedral Flower Festival on 10 July 1987. Built in 1941 it had also served Ely citizens after the Second World War until 1992 but, despite vigorous protest by local people, has now been largely demolished.

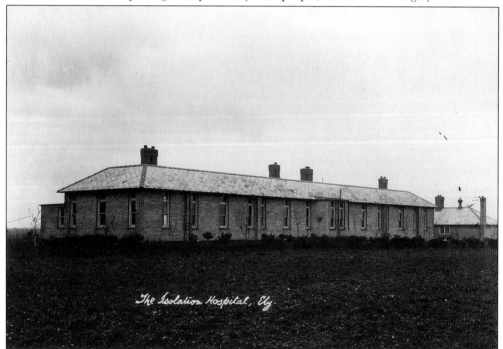

Close to the former Tower Hospital was an Isolation Hospital dreaded and feared by children who were sent there with, for example, scarlet fever or diphtheria. This grim view dates from the 1920s.

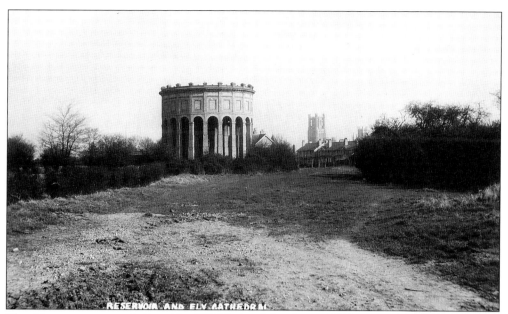

The Ely water tower, built with 618,000 local bricks in 1853, was said to be 'a perfect masterpiece, both in design and workmanship'. This elegant tower was replaced by a concrete structure on the same site in 1938/9.

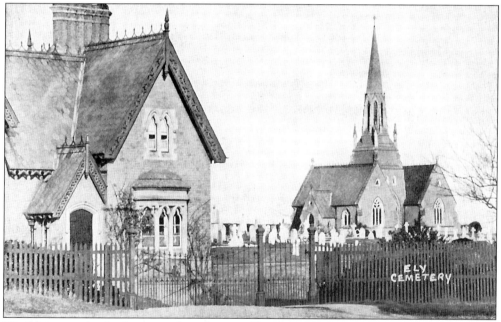

Ely Cemetery, the final resting place for most Ely citizens since 12 May 1855. The cemetery custodian lived in the house on the left just inside the main gates; the entrance was moved round the corner to Beech Lane, formerly Cemetery Lane, in 1989/90. The Church of England and the Non-conformist chapels were erected by local builder, Richard Freeman during 1855/56.

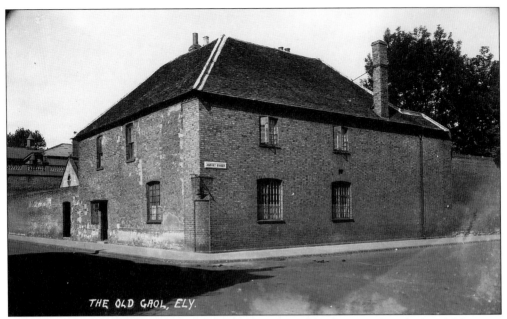

THE OLD GAOL, ELY.

Ely Gaol, now the Old Gaol, housed the Bishop's Prison for about one hundred and fifty years until 1836 when the jurisdiction of the bishops of Ely ceased. Parts of the building go back to the thirteenth and fourteenth centuries. It is now Ely Museum.

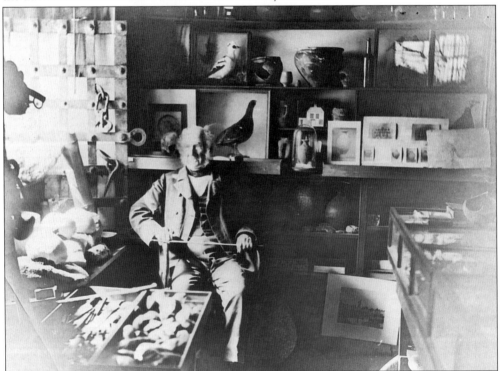

Marshall Fisher. He is pictured here in the museum that, with Mr Bard, he founded in 1849. The Ely Mechanics' Institute, 1842-1879, was housed in the Old Gaol then the home of the curator, Marshall Fisher. Note the prison door on the left.

Six
Churches and Chapels

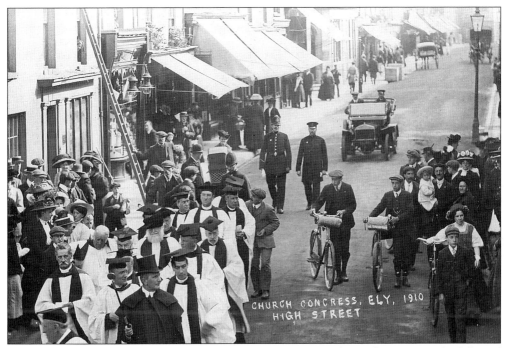

Church Congress, 1910. The progress of this procession along the High Street can be followed in a series of Tom Bolton's photographs. The street lights, the car, the horse and cart, the bicycles and the clothes, especially the ladies' hats, all add to the interest. What is Mr Roythorne doing with the ladder set against the premises of Pashlar & Co., house decorators?

St Mary's fourteenth century spire and earlier Lady Chapel framed by two men gossiping; the man on the right is said to be Isaac Aspland, violinist and harpist, though a description of him as 'portly' and of 'theatrical bearing' hardly appears to fit the picture. His name appears in a list of cathedral choristers of 1824. In a list of residents of 1893, he lived next to the Maid's Head on Fore Hill just below Clements, the printers.

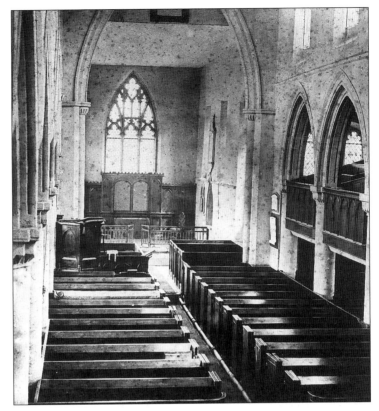

How much the interior of St Mary's has changed since this photograph was taken before the 1876 restoration. Galleries were removed from three sides and the boards (probably with the Lord's prayer and the ten commandments written on them) were removed from behind the altar. More recently a few pews were removed to make way for a nave altar.

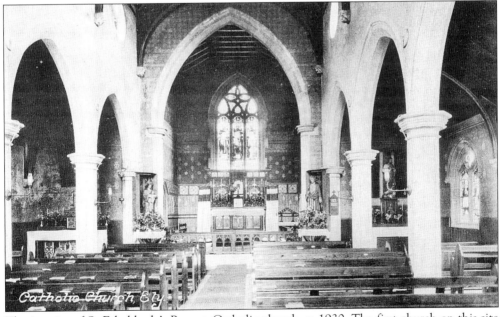

The interior of St Etheldreda's Roman Catholic church, c. 1930. The first church on this site was built in 1892 but was replaced by the present structure which was officially opened on 17 October 1903, the feast of St Etheldreda's Translation.

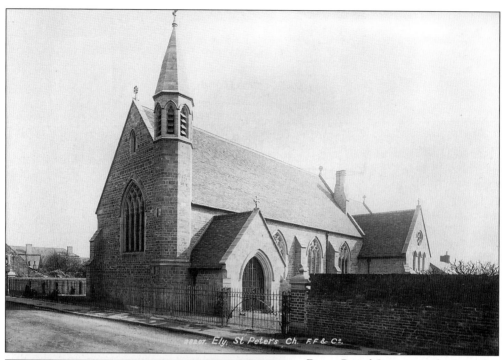

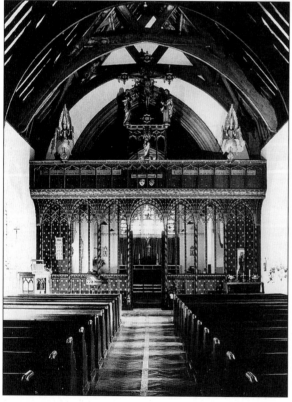

Down Broad Street, not far from the station and therefore in a then growing part of the city, showing St Peter's, a chapel of ease, which was dedicated on 30 June 1890. Built by Catherine Maria Sparke in memory of her husband, Canon Sparke and designed by St John Aubyn it has a fine rood screen, an early work by Sir Ninian Comper. His later work can be seen in a stained glass window and a reredos in Bishop West's chapel in the cathedral.

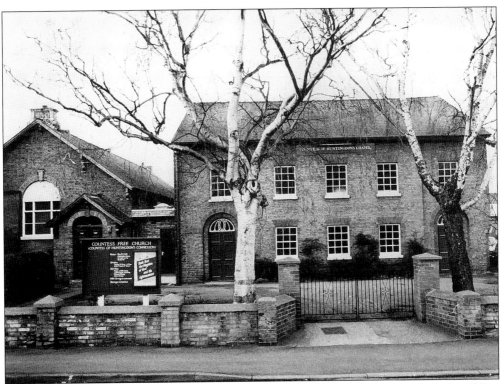

The Countess of Huntingdon's chapel in Chapel Street is a typical 'meeting house' building probably erected in 1793.

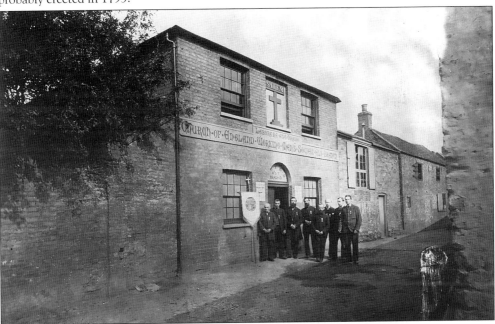

The Church of England Working Men's Society, Ely Branch, gathered outside their meeting room, formerly the Salem chapel, c. 1890. The building is hidden away in Chequer Lane behind Bonnet's bakery; it is now used as a store.

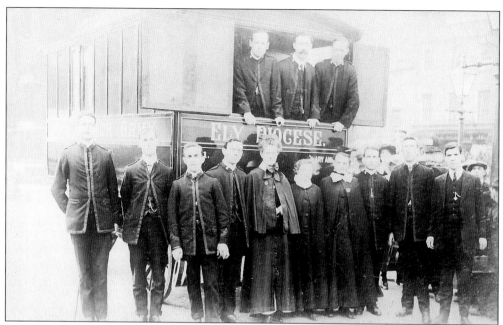

This photograph of church army workers in the Ely Diocese was taken, not by Tom Bolton, but by Starr & Rignall whose premises were opposite the Lamb Hotel.

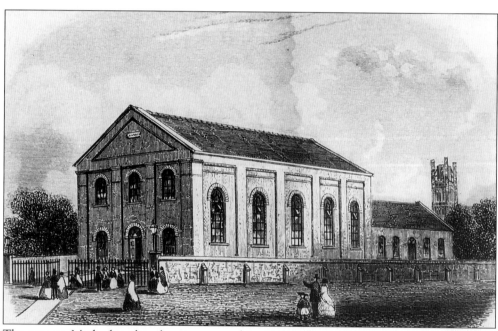

The present Methodist chapel as it appeared in 1859, when it was known as the Wesleyan chapel. The Wesleyan Methodist chapel was opened in 1818 although Methodism in Ely is said to have resulted directly from the visit of John Wesley in November 1774. A complete refurbishment took place in 1904. Sadly, the fall of the ceiling has made the chapel unusable at present. The old schoolroom, seen here on the right, was replaced by a series of rooms which were opened on 15 May 1993.

Seven
Cathedral and Monastery

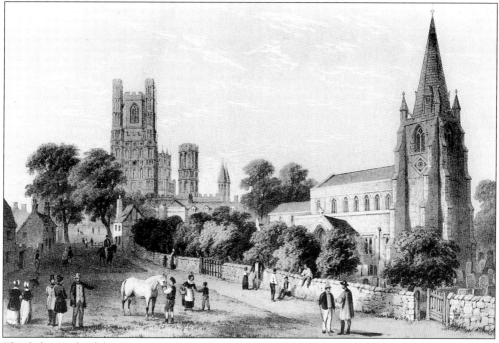

This lithograph of the Horse Fair links the cathedral with St Mary's church, *c.* 1845. Horse Fairs were held on St Mary's Green during the nineteenth century and gradually died out during the twentieth century. St Mary's church was begun at the end of the twelfth century, although it was built mainly in the fourteenth. It accommodated one of Ely's parishes the other being that of Holy Trinity Parish, accommodated in the Lady Chapel from 1566 to 1938 when it was united with St Mary's to form the Parish of Ely. The small white cottage still stands at the end of Church Lane, the former Lardners Lane ran alongside the churchyard providing the western boundary of properties in Church Lane.

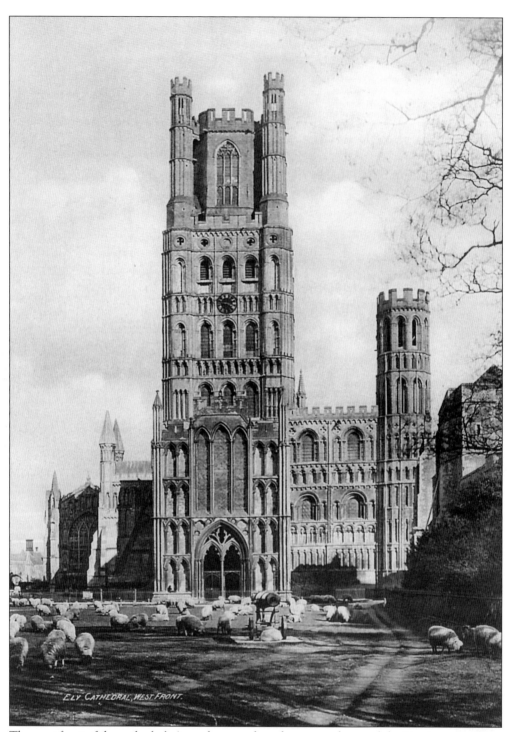

ELY CATHEDRAL, WEST FRONT.

The west front of the cathedral. A rural scene when sheep grazed around the Russian cannon on Palace Green and there were still railings, removed during the Second World War, which provided an eastern boundary between the Palace Green and the road. There is some doubt that the north west transept was ever completed.

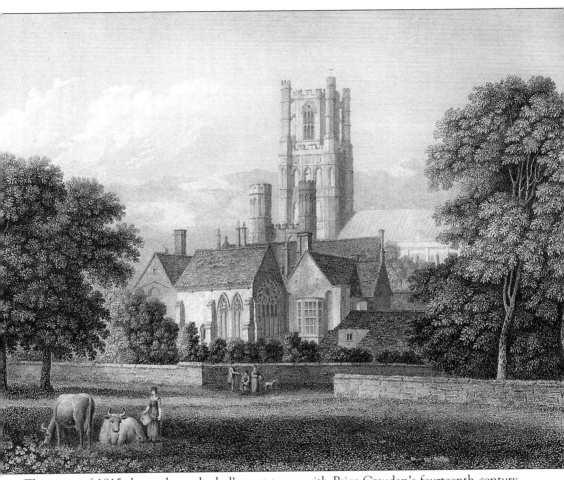

This print of 1815 shows the cathedral's west tower with Prior Crauden's fourteenth century chapel and the priory buildings in the foreground. Both chapel and priory are now used by the King's School. The school was founded by statute in 1541 though it is linked with the early eleventh century when King Edward the Confessor, as a prince, was brought to Ely by his parents as an oblate.

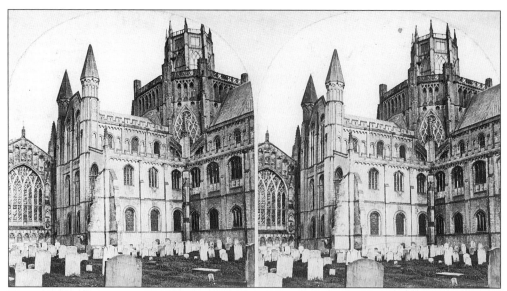

These early stereoscopic pictures taken in the early 1860s show the graveyard on Cross Green, which was cleared sometime around 1961, and the lantern tower as it was after restoration by James Essex in the eighteenth century. On the left is the west window of the Lady Chapel.

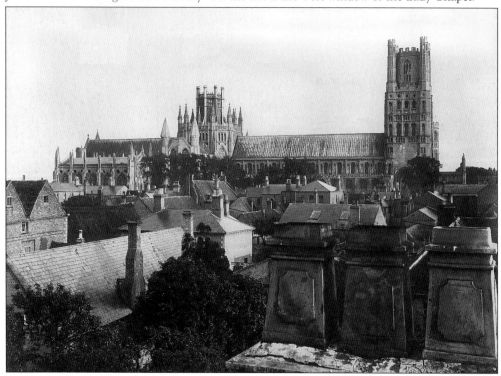

The north side of the cathedral seen above the buildings of Market Street and High Street. On the left is the long roof of the Registrar's Office which was built in 1868 for £430. It began its life as a junior school but changed to a mixed infant's school which closed in 1953. On the right the chimneys of the Sessions House can be seen. The lantern tower was restored to something representing the pre-Essex changes by Sir George Gilbert Scott in the nineteenth century.

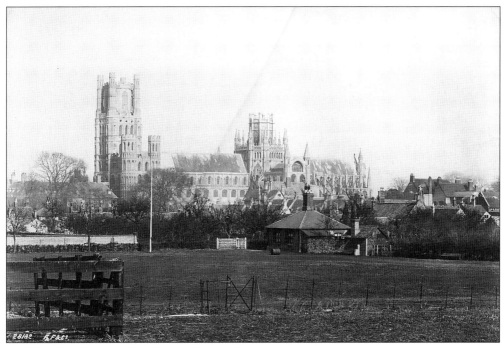

The south side of the cathedral seen from one of the King's School playing fields in Barton Road. The small house in the foreground was built for £100 by Richard Freeman, a local builder, as a model cottage.

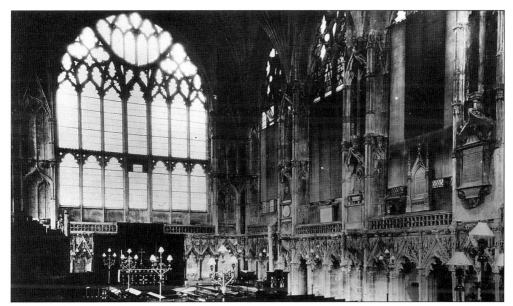

The interior of the Lady Chapel looking eastwards when it was in use as a parish church early in the twentieth century. A careful look reveals many details; a stovepipe apparently springing from the pulpit but in fact from a 'tortoise' type stove behind it, parish memorials now in the vestry, long sun blinds on the south facing windows and a very different altar frontal and surround from that in use today and, of course, the rows of wooden benches have gone.

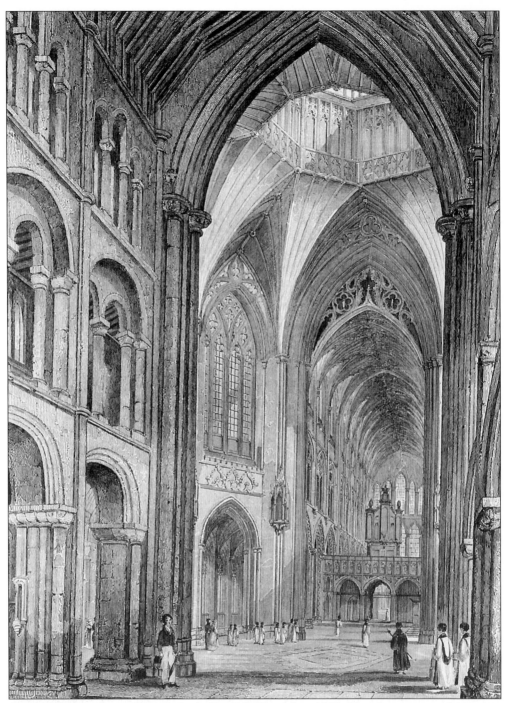

A print of the interior of Ely Cathedral by R.B. Harraden, 1830. The choir screen of that time with the organ on the top, blocks the view of the east end. At this time there were no painted panels hiding the timbers of the nave roof, no painted angels in the lantern tower, no prophets in the niches above the octagon arches and apparently no seating.

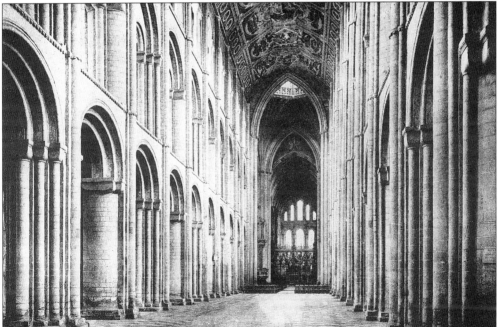

Little has changed in this view of the nave, looking toward the west, since Bishop Yorke donated most of the sixteenth century French glass in the west window. Today the floor is hidden by rows of chairs necessary for large services, concerts, Open University degree days and now in 1997 a base for a magnificent flower festival. Since 1986 there has been a desk near the tower arch where visitors pay to view the building on weekdays, a necessity if the building is to remain open outside service hours.

Much was changed during the latter half of the nineteenth century when the nave roof was boarded in and painted, the choir stalls removed to their present position, carved panels by Mr Abeloos of Louvain inserted above, a new choir screen erected and the grand organ case and organ placed on the north side. The paving too has changed and some seating is provided.

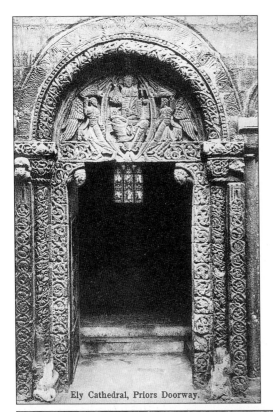

Ely Cathedral, Priors Doorway.

The Prior's Doorway, dating about 1130, is one of the glories of Ely cathedral with its wonderful rich carving. In 1994 it was enclosed by the continuation of a section of cloister after it had been exposed to the weather for three hundred years or more.

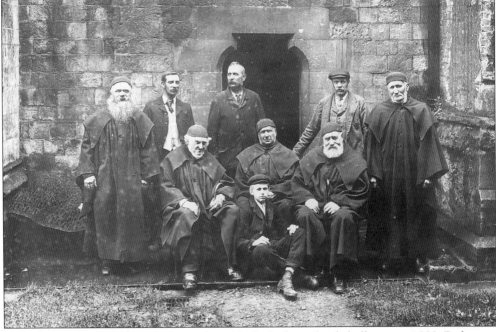

Cathedral Bedesmen, when they wore long black cloaks and red-skull caps, *c.* 1900. Bedesmen assist the vergers in their many duties about the building. Back row: Bearcock, Scarlet Everett, Fruim, Vail, Cooper. Front row: Hitch, -?- , Cook and George Vail at the front.

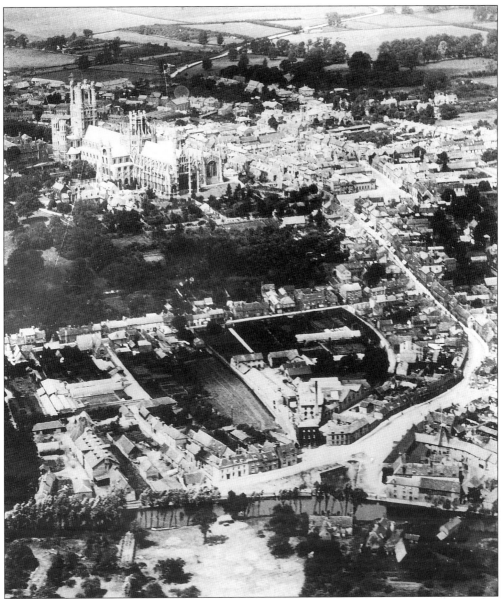

Ely and the cathedral from the south east, 1920. This fascinating view shows the river running across the bottom of the picture with the main road clearly leading up to the Market Place and the cathedral as it has done for centuries. Note the houses on Babylon, and the large unbuilt areas of garden and orchard on either side of Broad Street which runs across the middle of the photograph.

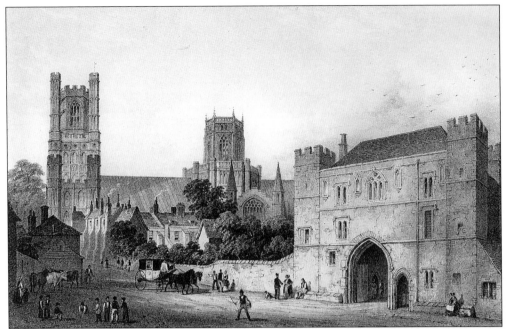

The view along the Gallery, 1845. All the buildings, with the exception of the cathedral, are now used by the King's School and have changed little during the last one hundred and fifty years. The biggest change is in the lantern tower; here the Essex restoration is clearly seen once again. The Porta, on the right, was built at the end of the fourteenth century.

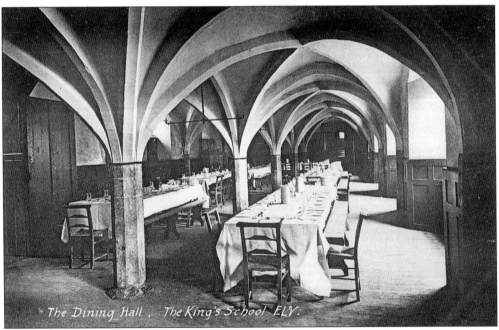

Part of the range of buildings along the Gallery. This vaulted room, was used as the King's School's dining hall.

94

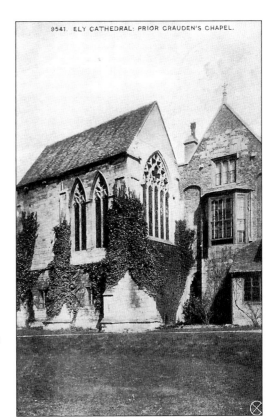

Prior Crauden's chapel, built in the fourteenth century, as a private chapel for the Prior of the monastery. It was restored in 1857/8 and 'after three centuries of profanation and defilement', when it had been used as a house and then fallen into a ruinous state, was ready for use by the King's School. Occasionally the cathedral lay clerks sing the service of compline there. The chapel has a unique medieval tiled floor which includes a depiction of Adam and Eve with the serpent.

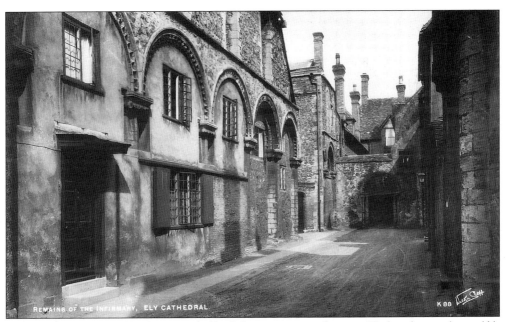

REMAINS OF THE INFIRMARY, ELY CATHEDRAL. K 88

Firmary Lane. Originally the main hall of the monastic infirmary. Today the partly twelfth century Powcher's Hall seen on the left, the Black Hostelry opposite and the house at the far end provide homes for the clergy. Near here was the blood-letting house of the monastery.

95

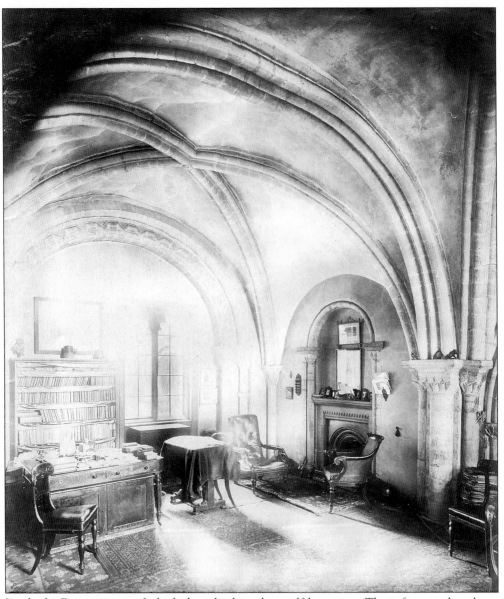

Inside the Deanery, part of which dates back to the twelfth century. The infirmary chapel was at the end of the lane where the Cathedral Offices and the Deanery are now. This vaulted room is the study of the present Dean of Ely.

Eight
The River Great Ouse

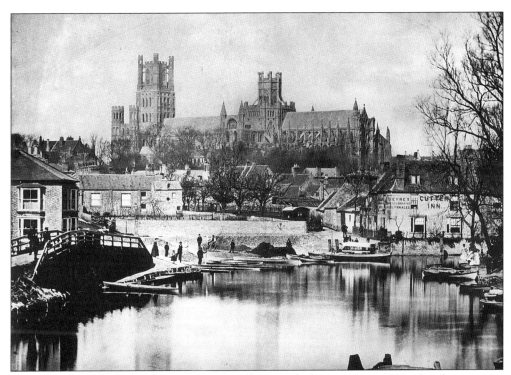

Ely cathedral viewed from the River Ouse, a photograph that pre-dates 1892 when houses were built near the Cutter. On the left we see a house occupied for many years by boat-builder Ted Appleyard, on the right the Cutter Inn which advertises Eyre's Celebrated Lynn Ales. Situated on the higher part of the city the cathedral dominates the skyline both within Ely and from afar.

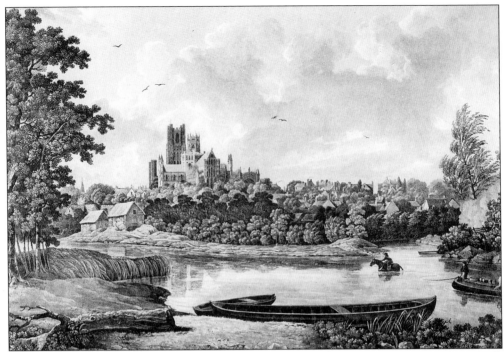

The river and cathedral, 1810. Viewed from a position to the right of the previous photograph probably taken from the Carmuckhill Bridge end of Babylon, the area over the river, this print shows a different perspective of the cathedral. The man on horseback is leading the barge, to the right of the picture, across a very shallow stretch of river.

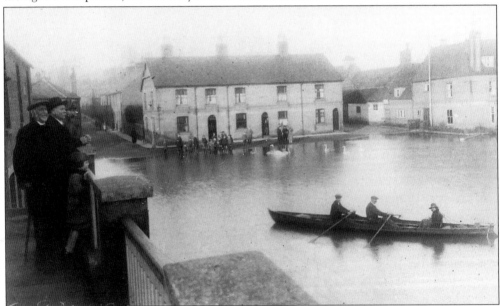

Viewed from the boathouse balcony, the flooded river attracts some attention in January 1928. This area and the nearby towpath were regularly flooded in the spring until fenland drainage was improved after the Second World War. On the left is Appleyard's Boathouse, now a restaurant and café, Victoria Street, the 1892 houses, Cutter Lane and The Cutter.

Barges moored across from The Quay to the area called Babylon which was known to have been occupied since the thirteenth century. Steam tugs pulled lines of barges which were steered using the long projecting pole seen on the middle barge.

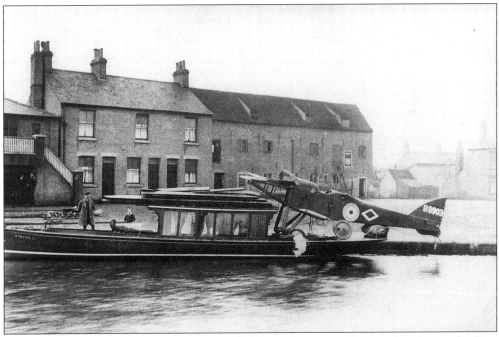

The Pattie, 1916. This small boat, often took fishing parties on the river but during the First World War was used to retrieve this plane which came down between the Bedford Rivers. The old granary was demolished to make way for town houses built in 1971.

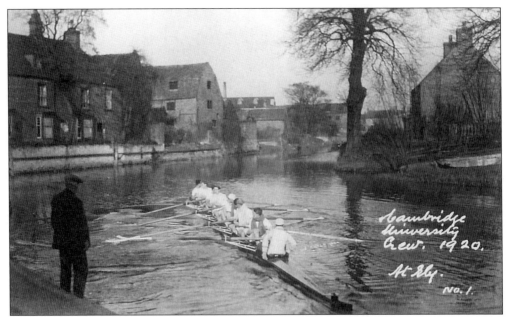

Cambridge University Boat Race Crew training, 1920. The crew still trains on part of the Ouse near Ely and has its own boathouse on Babylon. In this picture, just above the boat, is the old Steward's mill, in the seventeenth century owned by the Stuntney family, which was pulled down in the 1960s to allow space for the Riverside Walk which opened in 1968. An unofficial Oxford/Cambridge boat race took place near Queen Adelaide during the Second World War and Oxford won.

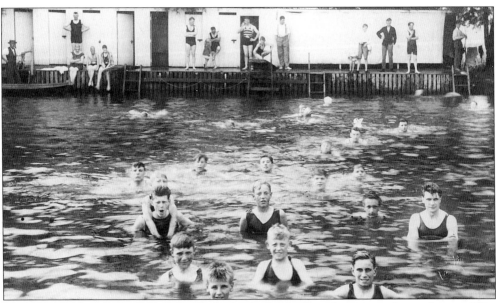

Swimming in the river in the 1930s. The bathing place, a short distance to the south east of Ely, was popular until the new pool, officially opened on 22 July 1934, was available.

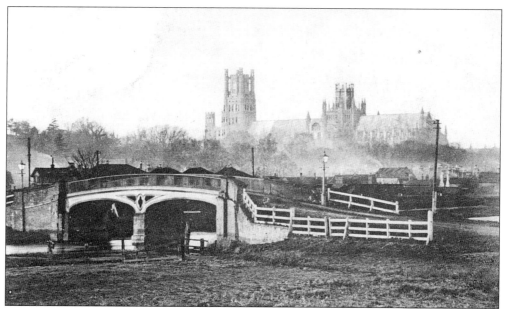

Ely High Bridge. Across the Ouse on the road to Stuntney a 'new and handsome bridge was built of stone' in 1833.

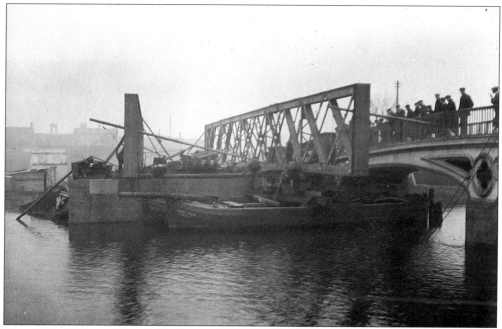

The High Bridge, 1908. Officially opened in 1910 the new bridge is shown here under construction. This too was replaced in 1981 by a bridge built on the site of the 1833 bridge and is the present structure. A little to the north-west, the 1896 railway bridge over the river is still in use.

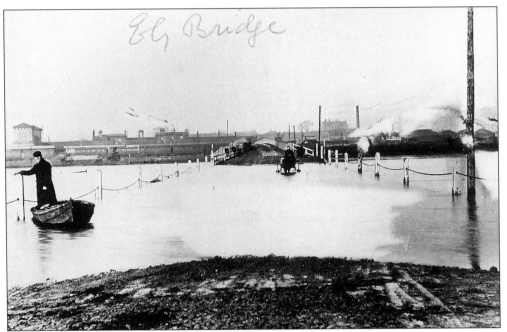

Floods in the 1890s. The water is flooding out over the washland between the banks on either side of the river. To the left is Ely railway station, approached by a steam train perhaps from Norwich, King's Lynn or Peterborough

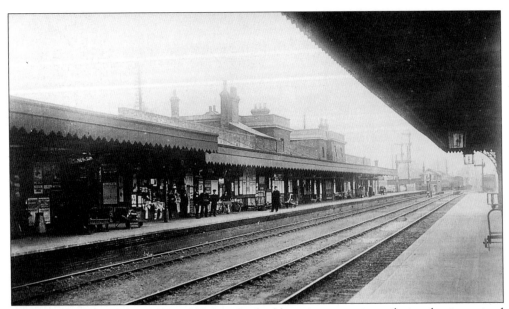

Ely Railway Station opened in 1845 but the building, 'an extensive pile in pleasing mixed Grecian and Italian style' was not completed until 1847.

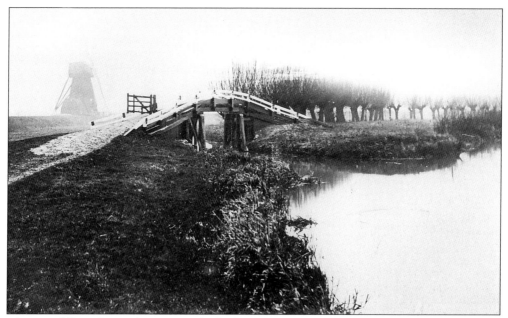

The Overfall Bridge in the 1890s. The bridge and mill were near the bend in the road along Queen Adelaide Way near the present pumping station.

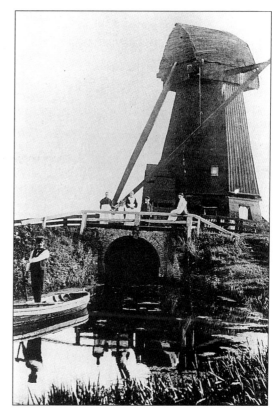

Old Overfall Mill, Ely. Robert Cross, whose ancestors lived here for about one hundred and fifty years, is in his boat. The wooden bridge seen above has been replaced with one of brick. This was a drainage mill.

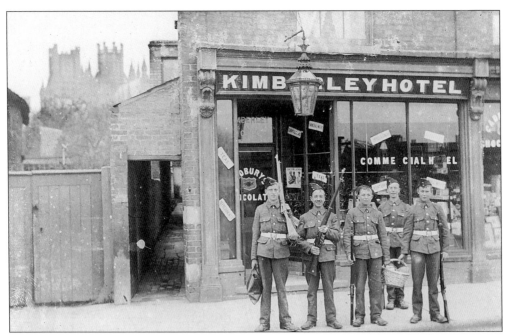

The Kimberley Hotel, Broad Street provided hospitality for Sheffielders who for many years flocked to Ely to fish for dace, roach, perch, tench, bream and eels. Here a group of lads with Martini Henry rifles appear to have been shopping!

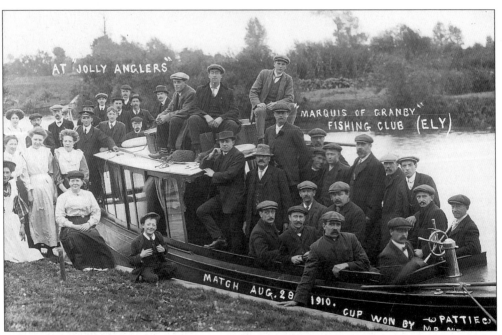

The Pattie in use by a group of fishermen from the Marquis of Granby in Victoria Street who had gone to the nearby Jolly Anglers at Hilgay, 28 August 1910. The cup was won by well-known Ely angler Arthur Meadows.

Farm and Factory

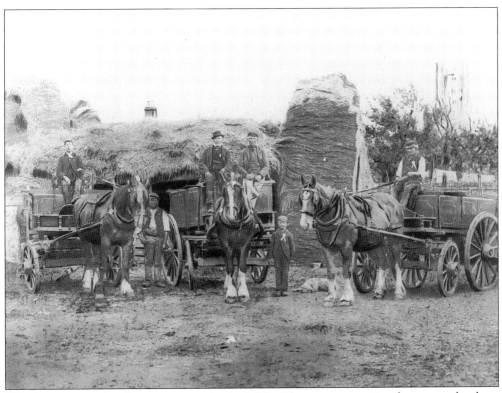

Shire horses at work pulling water carts in the 1890s. The men are wearing favours, so the three water carts could be about to leave for a show.

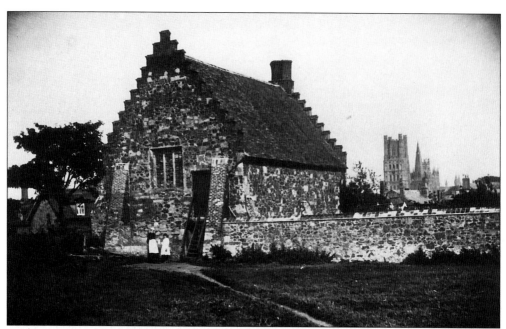

St John's Farm, 1892. This building, with the nearby barn, was once part of the hospitals of St John and St Mary Magdalene. Records tell that the two hospitals were united in 1240 and that the area came into the ownership of Clare College, Cambridge and remained so until 1925 when the farm was sold to the Runcimans.

St John's Farm, on the corner of West End and St John's Road, is shown here in the 1920s. It was a short distance up the latter road that five men were hanged following the Ely and Littleport Riots of 1816.

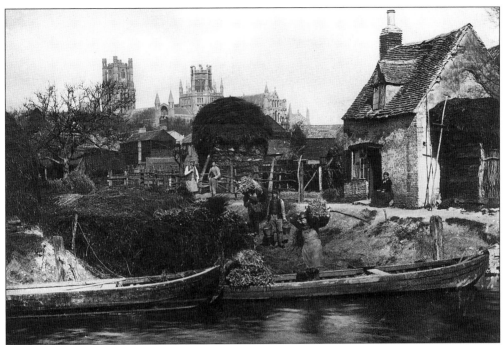

Fear's rod yard at the river end of the Three Blackbirds site, 1880s. Here osiers, probably grown at nearby holts, were landed to be prepared for basket making; a relatively important industry in Ely during the nineteenth century.

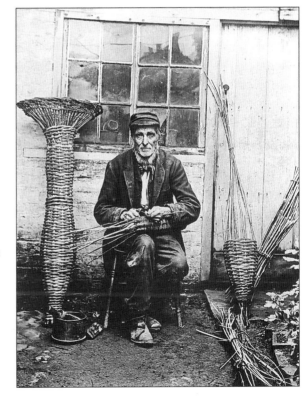

Paul Gotobed in 1893. He is seen here making an eel trap, smaller than the eel grig which stands beside him. The Domesday Book states that 24,000 eels were caught, presumably annually, near Stuntney. At this time the river ran at the foot of Stuntney hill. A relatively small number of eels are still caught today which are sold locally and in London.

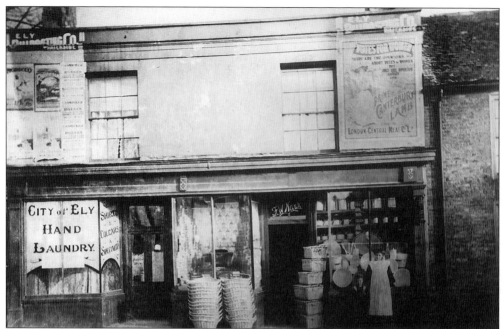

Nash's on the east side of the Market Place. The premises of Nash & Co., General Supply Stores, on the right of the entrance to The Vineyards had a laundry, run by the same family, at the rear. Note the laundry baskets stacked at the front of the hardware store and the interesting poster; 'Votes for women. There are two opinions about votes for women but only one opinion about the Prime Canterbury Lamb from the London Central Meat Co. Ltd.'

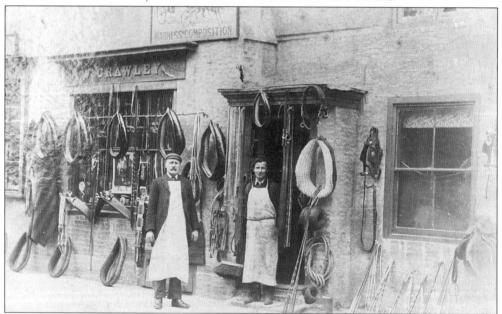

W. Crawley, c. 1908. Horses were still much used in the first thirty to forty years of the twentieth century and so there was much demand for the work of this firm and later for that of F. Wilson, saddler, in Market Street. The premises can be recognised as those of the present Trustee Savings bank even though they have been rebuilt since the Second World War.

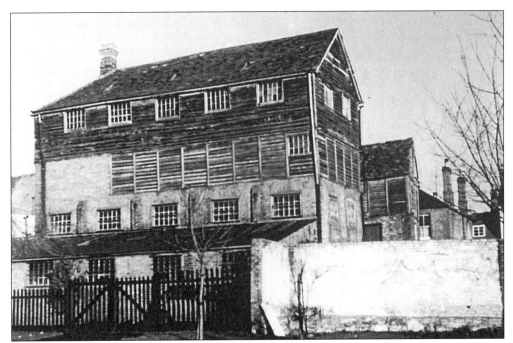

The leather factory of T. Blakeman & Son curried and tanned leather from 1836 when it took over from the previous owner. The factory, behind Broad Street was at its busiest during the First World War when boots were made for the French army but by the 1930s the business had dwindled and when it was sold in 1944 it became merely retail. The factory and adjoining properties were demolished in 1973.

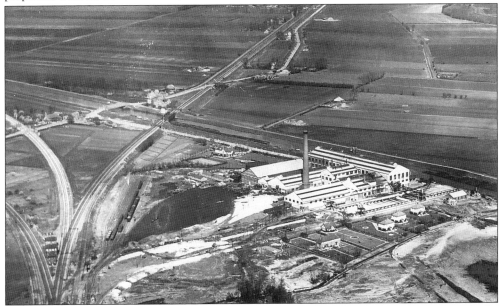

Ely Beet Sugar Factory in 1930. Opening in October 1925 at Turbetsey near Queen Adelaide, the factory had its own railway sidings, owned a fleet of fifty barges and at one time had the largest workforce in the city with 500 employees. The factory closed after the 1980-81 'campaign' and now belongs to the Potter Group.

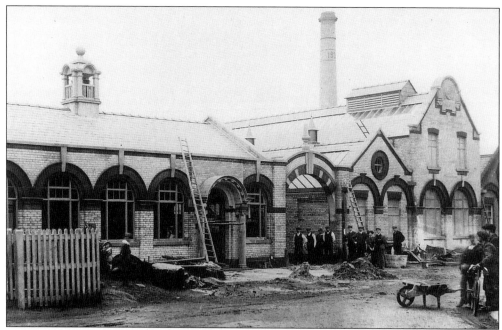

Granger's Fruit Preserving Company opened in 1890 and after various other owners and uses was demolished to make way for St Martin's Walk in 1987. Locally it was known as the 'jam factory' and was remembered for the strongly smelling barrels which contained fruit pulp often stacked alongside the pathway to The Vineyards.

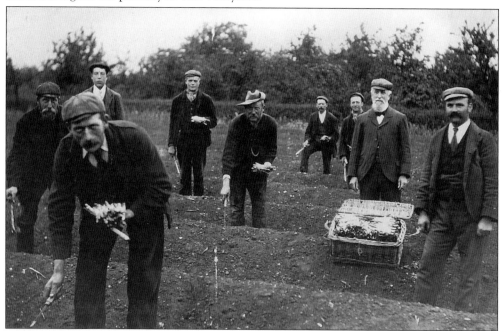

Although on a much smaller scale the growing of asparagus was of some importance; much was sent to London. Here the spears are cut at W.B. Granger's asparagus beds in The Vineyards at the beginning of the twentieth century. In contrast a relatively new Cambridgeshire Business Park, in Angel Drove, has gradually grown from the 1980s and is now flourishing.

Ten
Commemoration and Celebration

The Coronation of Edward VII, 1902. Here a group of citizens who have been taking part in the jollifications are gathered outside the bunting bedecked Appleyard's Boathouse, now The Old Boathouse Restaurant and Cafe.

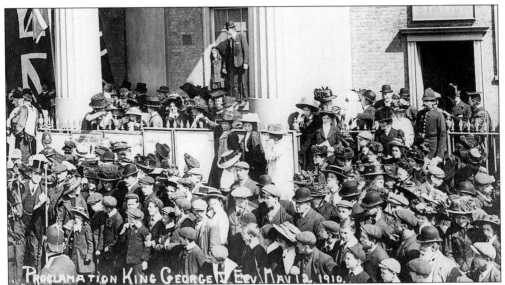

The Proclamation of King George V, Ely, 12 May 1910. This took place outside Shire Hall, now the Sessions Court, the police station was then in the southern end of the building.

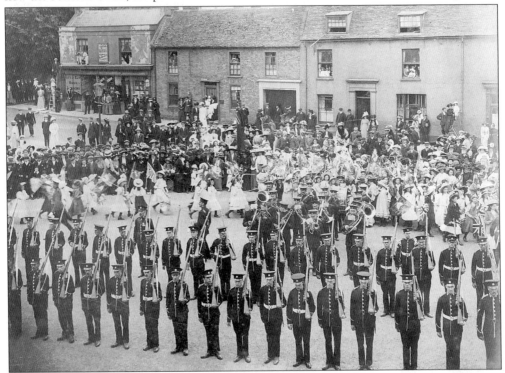

The Coronation of George V, 22 June 1911. The crowd awaits the Feu de Joie to be fired by members of the Territorials of the Ely Company of the Cambridgeshire Regiment on the Market Place. The celebrations concluded with a dinner for two hundred people aged over seventy, a full sports programme, a presentation of coronation mugs to school children, a promenade concert and, finally, a display of fireworks. In the background are Nash's and the present *Cambridge Evening News* offices.

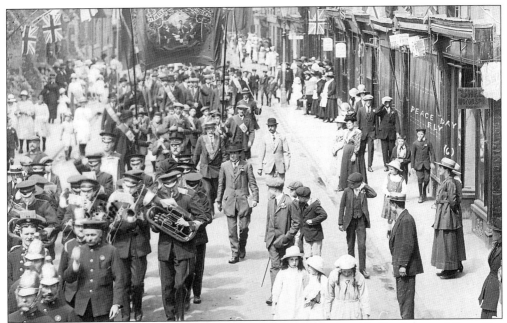

Peace Day, 1919. The procession passes along High Street, the band led by firemen followed by members of the City of Ely Jubilee Juvenile Foresters who carry their large banner. All respectable shopkeepers have, as was usual on Sundays and holidays, put wooden shutters over the shop windows

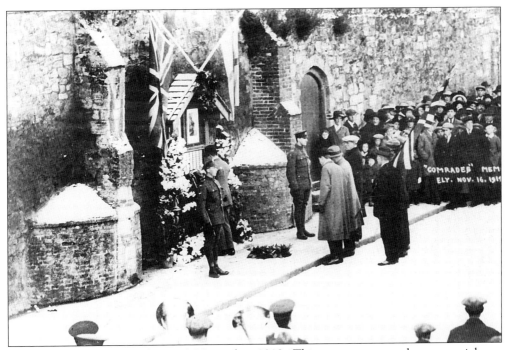

The 'Comrades' Memorial on 16 November 1919. This temporary wooden memorial was replaced with the more permanent war shrine.

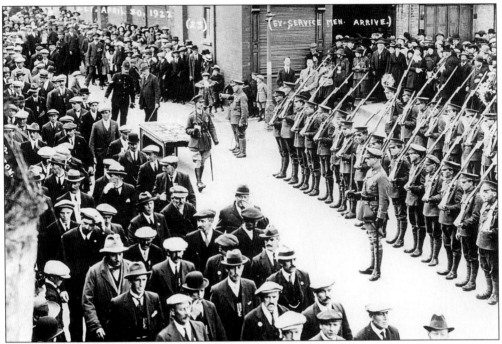

The Dedication of the war shrine, 30 April 1922. The Market Place was packed with onlookers and there was scarcely room for the members of the City of Ely and of the Railway Bands to play. Lieutenant R. Plumb is the officer in front of the men standing to attention.

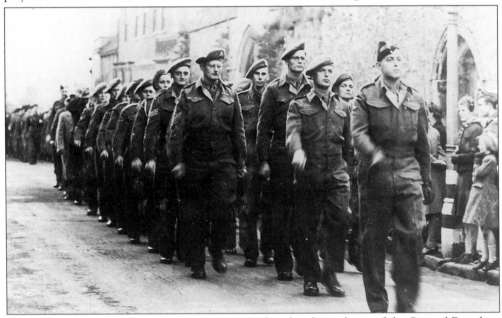

Remembrance Sunday, 1945. Colonel J.G.A. Beckett heads a column of the Second Battalion of the Cambridgeshire Regiment, survivors of Japanese prison camps following the surrender of Singapore in 1942. He became a much respected County, District and Parish Councillor, High Sheriff for Cambridgeshire, Mayor of Ely and the first honorary alderman of the District Council.

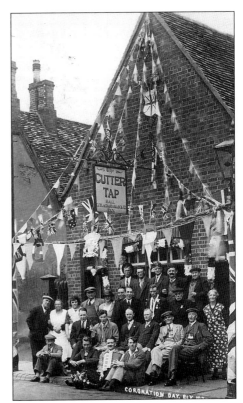

Coronation Day, 1937. Outside the Cutter Tap, next to the former Three Blackbirds in Broad Street a group of citizens gathered to mark the occasion and were photographed by Tom Bolton.

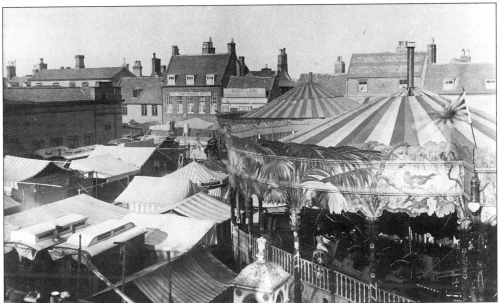

Ely Fair before the First World War. A fair had been held here since the days of the monastery until 1994; it now has no settled home and is declining in popularity. The fair of St Audrey, an alternative name for Etheldreda, goes back to a charter granted by Henry I. Necklaces, known as St Audrey's lace, were sold at Ely and by the seventeenth century had become symbolic of cheap and gaudy finery or 'tawdry'.

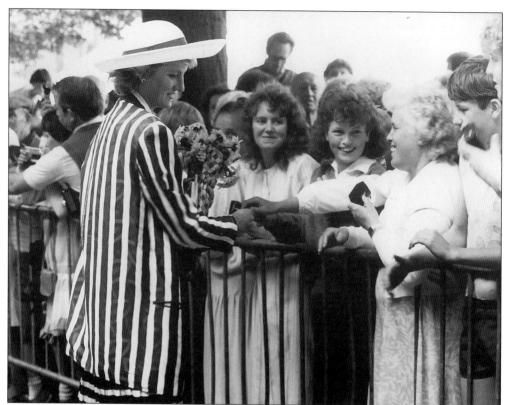

Diana, Princess of Wales, or HRH The Princess of Wales, as she was then, visited Ely on 9 July 1987 to open Ely Cathedral Festival of Flowers, after which she attended evensong in the Lady Chapel.

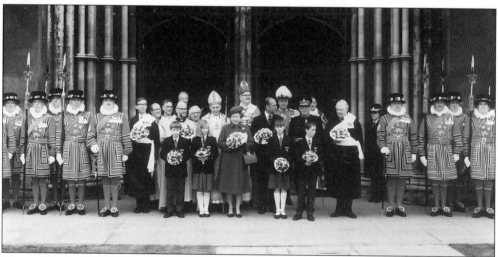

Queen Elizabeth II, 16 April 1987. The Queen, the Duke of Edinburgh, The Right Reverend Peter Walker, Bishop of Ely, The Very Reverend Bill Patterson, Dean of Ely and other members of the cathedral staff with Royal Almonry officials pictured outside the cathedral after the Queen had distributed the Royal Maundy. The four 'Children of the Almonry' at Ely were David Lawrence, Emily Lawrence, Samantha King and Adam O'Loughlin.

Eleven
The Villages

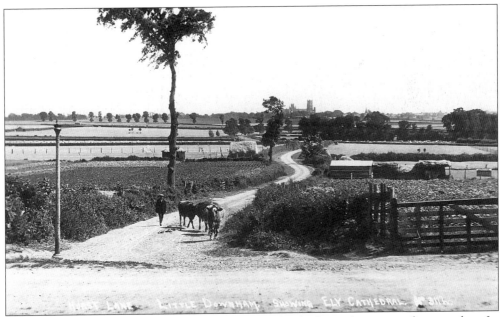

Before the drainage of the fens Ely stood on an island, above the surrounding marshes. Its cathedral is visible for many miles, dominating the landscape and drawing people towards it. Drainage of the fens created good agricultural land where once was water. Seen here from Little Downham, just one of the villages which clustered on to the higher land of the old Island of Ely.

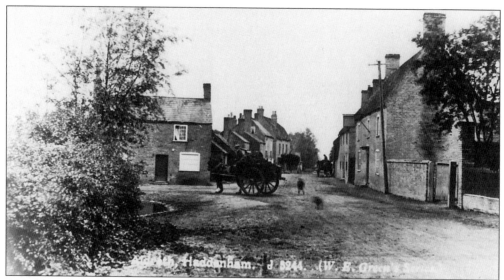

Aldreth in the 1920s. After William the Conqueror had successfully tamed most of England, following the Battle of Hastings in 1066, one area of resistance remained. Hereward the Wake and his followers turned the remote island of Ely into a fortress, defying the Norman invaders who were unable to find or force their way through the fens to defeat him. One of the main trackways linking the Isle with the rest of Cambridgeshire runs from Giants Hill near Rampton to the hamlet of Aldreth. This remained the principal route between Cambridge and Ely until the turnpike roads of the eighteenth century were built.

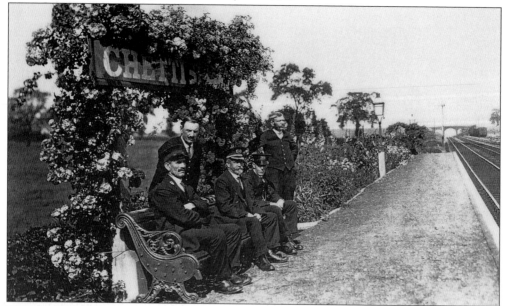

The coming of the turnpike roads improved communications, allowing stagecoaches to travel through an area still poorly served by roads. But it was the arrival of the railway to Ely and beyond in 1845 which gave residents the opportunity for the first time of travel to the wide world beyond the fens. Chettisham, a small hamlet on the old road to Littleport and with an ancient church, gained a station on the route to Peterborough, providing employment for a station master and his staff.

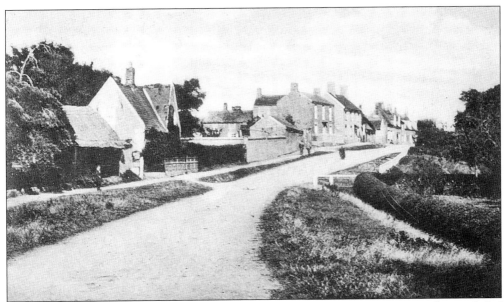

Once on its own island, separated from Ely by the West Fen, Coveney is still a secluded community. The two great man-made Bedford Rivers of the seventeenth century sliced through the parish, separating it from its sister settlement of Manea. During the hardships which followed the end of the Napoleonic War, which led its near neighbours in Littleport to riot, Coveney folk felt themselves sufficiently aggrieved in 1819 to take possession of charity lands, and chance a similar fate. Then a few years later at Manea a Socialist community was established, when money was abolished, houses were centrally heated and all worked one for another. Such a situation could not flourish even in fenland and it collapsed within twelve months.

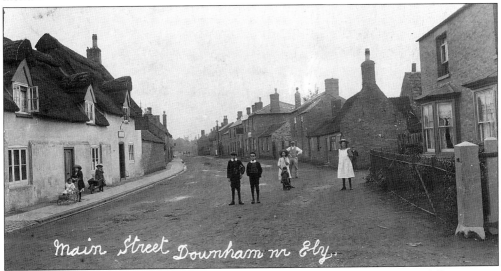

Main Street Downham nr Ely.

Built on a peninsula of land jutting out into the fen, Downham, called 'Little' to differentiate it from the larger, market town along the road in Norfolk, was a favourite haunt of the Bishops of Ely, who built themselves a palace, now an antiques centre. Here Lancelot Andrewes did his work as one of forty-seven translators of the Authorised Version of the Bible. The tradition of Molly Dancing was kept up here longer than anywhere else in the Eastern counties.

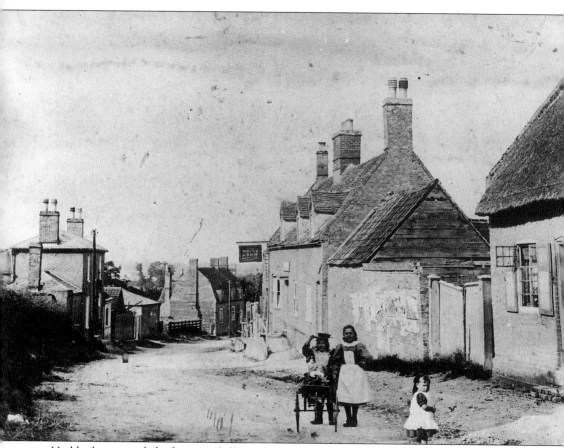

Haddenham stands high on its hill on the western fringes of the Isle of Ely. In March 1947 when heavy snow, a quick thaw and gales combined to breach the banks of the Great Ouse near Earith hundreds of fertile acres disappeared under water and Haddenham found itself once more on the shore-line. Station Road drops down from the village centre towards a former stop of the 'Grunty-Fen Express', the railway line from Ely to St Ives. It was a resting point too for Christopher Marlowe during a cycle tour of the fens just after the Great War. He arrived on Feast Day when William the Conqueror walked side by side with his old protagonist Hereward the Wake and Queen Elizabeth I chatted with Mary Queen of Scots. Men with bags on long poles pushed them into the faces of onlookers exclaiming 'Orspital. 'elp the orspital'. The hospital in question being Addenbrooke's at Cambridge and the occasion the festival of St Ovin, henchman to the foundress of Ely Cathedral, Saint Etheldreda. Ovin's stone cross, with its ancient inscription was once used as a doorstep in the village, now it stands in the cathedral.

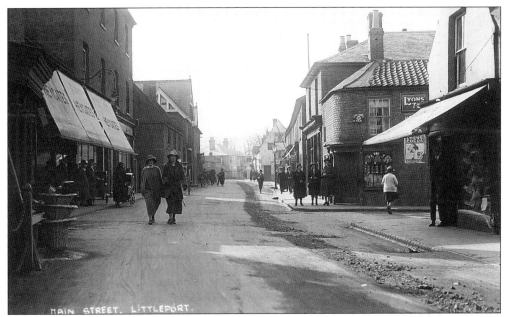

Littleport, the largest settlement, separate from Ely on its own island. Littleport's main claim to fame rests with the Riots of 1816 when local people sought redress from the hardships of fenland life in a protest first in their own village and later at Ely which brought in troops to put them down and the hangman to reap vengeance. The cells in which they were imprisoned before their execution can be seen in Ely's old gaol museum, which is well worth a visit.

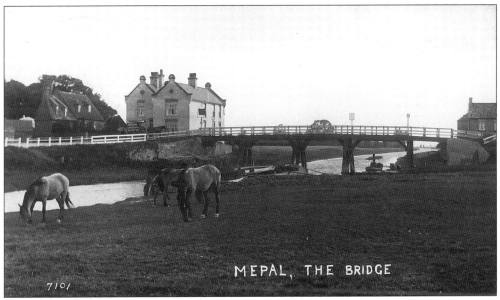

Mepal stands on the slopes of the isle directly alongside the two Bedford Rivers. They are spanned by bridges, though now not the wooden structure seen on this pictures. It was replaced in the 1930s by a new concrete bridge, and now has been by-passed altogether by a new structure on the improved road to Chatteris. That road carried the name Ireton's Way, named after a Cromwellian General who constructed the road from Chatteris to Ely to convey troops during the Civil War.

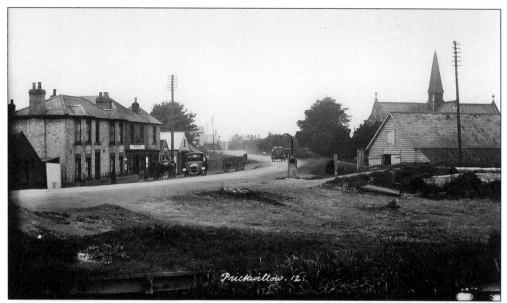

A small hamlet in the fens in the parish of Holy Trinity about four miles north east of Ely, Prickwillow now attracts visitors to view its Fen Drainage Museum where various diesel pumps which used to drain the fens are to be seen working. Its church, built in 1868, houses a marble font originally given to Ely cathedral in 1693.

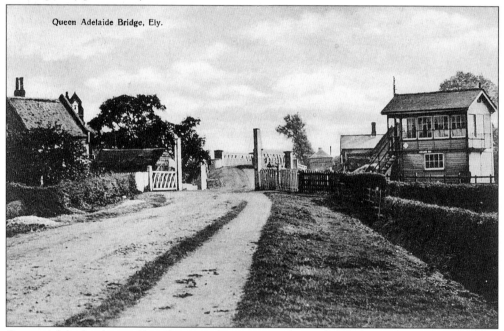

Queen Adelaide, the small settlement takes its name from a public house (now closed) which commemorated King William IV's Queen. There is no church, no shop or post office but it does have an impressive collection of railway tracks including three crossings, one railway bridge and the bridge over the Great Ouse River. It was here that the Ely Sugar Beet Factory was constructed in 1925 and once gave work to about eight hundred and fifty men. Now it is closed and the site used as a store for new motor cars.

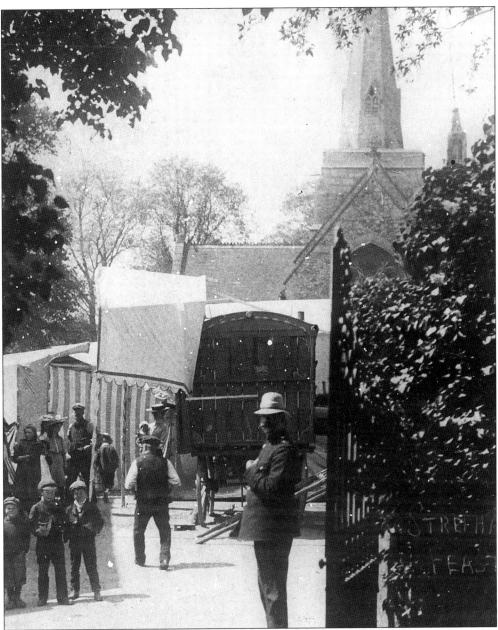

Fenland villages do not comprise the ancient, picturesque thatched cottages found elsewhere. This is largely due to fires which have swept the communities, as in the case of Stretham. An accidental fire starting in a blacksmith's shop on May Day in 1844, destroyed nearly one quarter of the village. Within a decade outbreaks of deliberate incendiarism devastated other areas. The village is noted for its cross, said to commemorate Bishop Morton, dating from the fifteenth century, and, beside the Old West River the giant steam pumping engine, rare survivor of the dozens which formerly performed the essential task of pumping water from the low-lying drains up into rivers. This has now been restored and can be seen working, but by an electric drive rather than its original steam power. It is seen here during the annual feast which is still commemorated on the third Sunday of May.

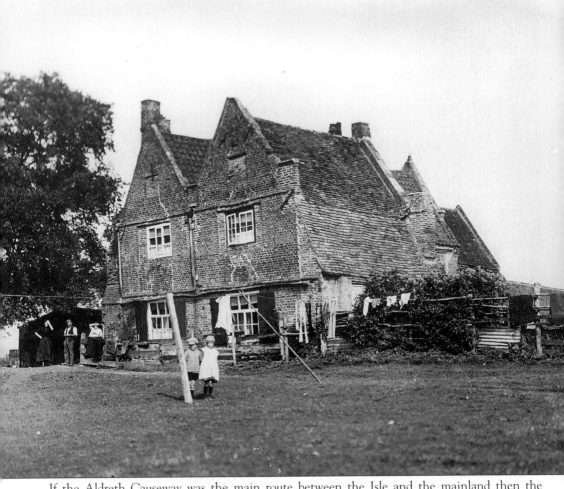

If the Aldreth Causeway was the main route between the Isle and the mainland then the causeway from Ely to Stuntney was the shortest and today's route brings the most spectacular views of the cathedral city. Standing proudly on the slopes stood Stuntney Hall, once owned by Oliver Cromwell which in recent years has been allowed to crumble into decay, but where work on reconstruction is now taking place.

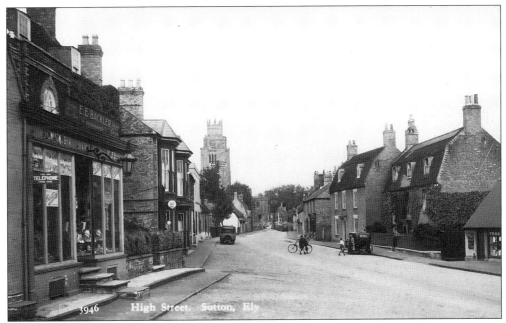

Sutton's church seems to resemble a light house, especially when glimpsed across acres of flooded fenland, as happened most recently in 1947. The village High Street clings to the edge of the island while lanes descend steeply to a lower level, some properties enjoying panoramic views of open countryside, others views of roofs of newly-built houses behind them. As with most villages its inhabitants once enjoyed a number of public houses each competing for a trade which, like the pubs themselves, has now declined.

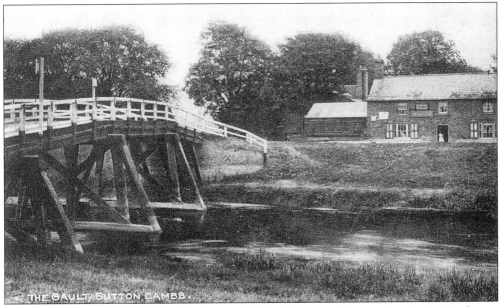

One public house which survives and prospers, though not at village prices, is the Anchor at Sutton Gault. Here bridges span both Old and New Bedford and an elevated footbridge crosses the Washlands between, a permanent reminder that when the floods come the green acres which are normally grazed by cattle disappear under water.

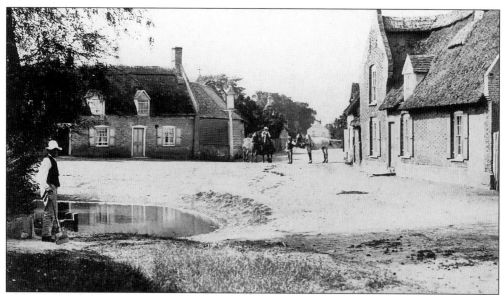

When the enclosure movement swept the area in the 1830s the residents of Little Thetford, a hamlet of Stretham, showed their disapproval by preventing the enclosure men getting to the church to fix the formal notice to the church door. Although the officials returned with a large escort more villagers had also arrived and won the day. They lost the battle however and enclosure came nonetheless - something to talk about in the Three Horse Shoes pub seen across the pond.

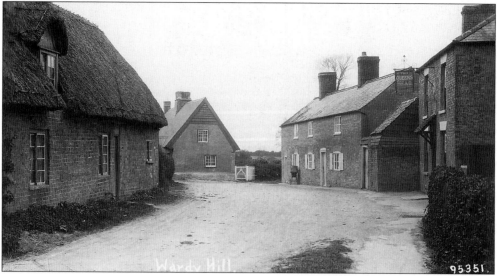

A particularly isolated off-shoot of Coveney, Wardy Hill, photographed here in 1929, was situated on the very edge of its own island, its name signifying a place from which a watch was kept for potential intruders venturing across the fenland. Its most famous character is David Cox of Wardy Hill - if he'd not died, would be here still. But David's gone, and his four wives, yet David's first, with all her tricks, lived till he was seventy-six. Fifteen years went swirling round since David placed her in the ground, but then a fair one crossed his path. At Coveney church the people stared, when the parson had declared, that David Cox, at ninety-one, with matrimony had not done. This happened in the 1830s, Fenmen had to be tough to survive!

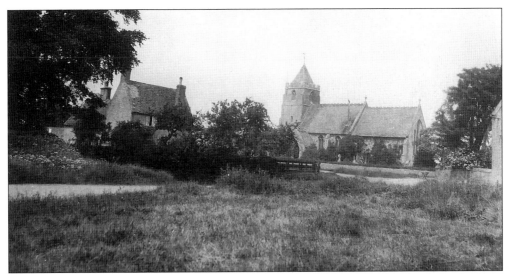

Wentworth in June 1930. By contrast Wentworth nestles quietly amongst its trees, the main street running at right-angles to the only road through it. It is edged by Grunty Fen, one of the last areas to be drained, which occupies the centre ground of the Island of Ely, a fen in the middle of an island surrounded by fen. Wentworth was a large settlement when recorded in the Domesday Book but subsequently declined until in 1428 there were only nine resident parishioners.

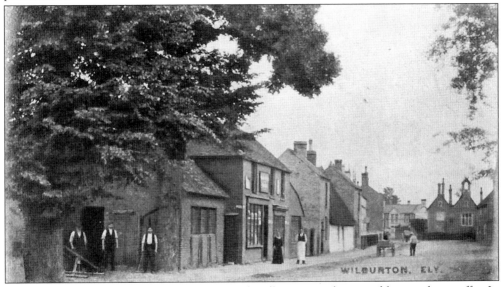

Like many villages the apparent tranquillity of Wilburton can be ruined by speeding traffic. In the inter-war years as fenland was adjusting to the impact of the motor car a new road was opened to link Wilburton to Cottenham with a new bridge over the old 'twenty pence ferry', a name whose origin is obscure, though it dates back at least four hundred years. To cope with that other disturber of the peace, the obstreperous villager, Wilburton had its own lock-up, though one tale tells how the village pest, a monster of a man with a temper to match, was imprisoned therein only to rant and rave and scratch at the ground beneath the door. Soon his hand appeared, then the top of his head, then his shoulders. Villagers scattered, seeking the local constable, but he, wise fellow, was nowhere to be found!

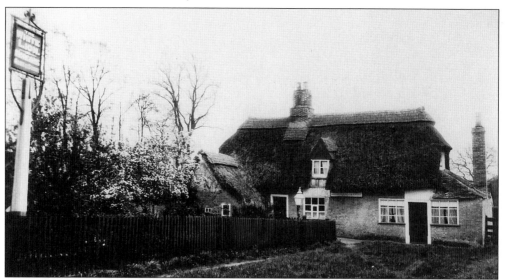

Witcham stands quietly off the Ely-Sutton-Chatteris road, except during the Second World War when the Isle of Ely played its part in the conflict by giving up farmland to accommodate two airfields. One was at Sutton, called Mepal to distinguish it from others with the same name, which blocked the main road, and traffic had to be re-routed through Witcham. It also gained a hutted camp which was later used as a Polish Resettlement Centre and a Women's Land Army Hostel, all bringing trade to this small settlement.

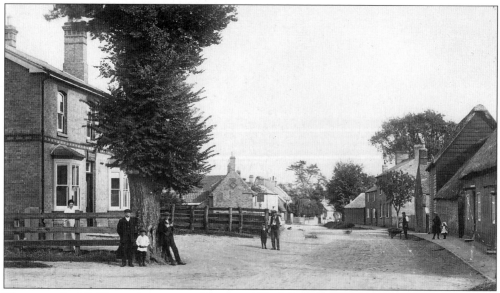

The second airfield was here at neighbouring Witchford and opened in June 1943. In late Autumn 1944 the Dutch railway workers decided to support the advancing Allies and went on strike. By way of retaliation Germans flooded large areas of Holland, effectively cutting off the rebellious area. Food supplies ran short forcing the Dutch to eat bulbs and their pets to remain alive. In April 1945 planes from Witchford dropped supplies of food to Vermuyden's countrymen, who reciprocated by sending their pumps to drain the Isle of Ely after the disastrous fenland floods of March 1947. The story of Witchford's war is told in a museum on the old airfield.